ABANDONED NEW JERSEY

FORGOTTEN SPACES OF THE GARDEN STATE

JOEL NADLER

AMERICA
THROUGH TIME®
ADDING COLOR TO AMERICAN HISTORY

America Through Time is an imprint of Fonthill Media LLC
www.through-time.com
office@through-time.com

Published by Arcadia Publishing by arrangement with Fonthill Media LLC
For all general information, please contact Arcadia Publishing:
Telephone: 843-853-2070
Fax: 843-853-0044
E-mail: sales@arcadiapublishing.com
For customer service and orders:
Toll-Free 1-888-313-2665

www.arcadiapublishing.com

First published 2022

Copyright © Joel Nadler 2022

ISBN 978-1-63499-388-3

Typeset in Trade Gothic LT Std
Printed and bound in England

CONTENTS

ACKNOWLEDGMENTS

I would like to thank everyone who made this book possible. First and foremost, my parents, who despite their concerns, often supported my interests and my drive to learn about abandoned places from the beginning. My professors at Goucher College, Tina Sheller and David Zurawik, helped me pursue my passion for historic preservation and photography. Phil and Jean Jaeger of the Cedar Grove Historical Society encouraged me to explore the preservation and documentation of historic places. I'd also like to thank the many friends I've made along the way. Without all of them, the photographs in this book would not have been possible. Thank you, Fonthill Media, for providing me this opportunity to share my photography.

This book is dedicated to the memory of Doria Howe, who always faithfully supported my work and encouraged me.

INTRODUCTION

New Jersey is littered with abandoned buildings. In small towns and big cities, on rural backroads and city streets, deserted structures haunt the state's landscape. Buildings that were once vibrant centers of human activity as homes, schools, theaters, churches, and hospitals are now derelict, hollow spaces of silence and decay.

Since the first Europeans settled in Bergen County in the 1600s, New Jersey has been a microcosm of American architecture.[1] Only reconstructions exist of the dwellings built by the earliest settlers, the Native American Lenape tribe. But across the Garden State, you can see authentic abandoned examples from every other era of architecture: from Dutch Colonial homes of the 1600s and Gothic Revival mansions of the 1800s, to more recent ranch houses and McMansions, to movie palaces and multiplexes, racetracks, and classic diners.

As a documentarian and preservationist, I feel obligated to share my experience, knowledge, and passion with you. I hope this book will generate thoughts and conversations about how we, as a society, wish to deal with the history and remains of these abandoned treasures. My goal is to bring awareness to the issues surrounding these endangered structures and help you understand the stories behind them. So much is lost when these buildings are left behind.

What is an abandoned building? According to New Jersey law, a public officer can declare a building abandoned if it hasn't been legally occupied for six months and meets any one of several criteria, including unpaid taxes—see NJ Rev Stat § 55:19-81 (2014).[2] I consider an abandoned building one that has fallen into heavy disrepair and that's no longer in use—run down, heavily damaged from environmental factors and neglected by its owners.

Historic preservation, sometimes called heritage preservation or heritage conservation, is a global movement to preserve and protect places, buildings, structures, objects, archaeological sites, and landscapes of historic significance. As a student of preservation, I believe in documenting places of cultural or historic importance even in their current state of disrepair to save their memory for future generations. The federal government has a program to document historic buildings (Historic American Buildings Survey) or historic structures (Historic American Engineering Record) before they are demolished; however, it's generally limited to historic properties affected by federal undertakings. As a result, many historic properties are lost without any documentation.

There are multiple programs to financially support historic preservation, including federal and state tax credits. On the federal level, historic preservation tax credits provide a 20% income tax credit for the rehabilitation of historic properties used for income-producing purposes. In addition, the New Jersey Economic Recovery Act of 2020 (ERA) includes a tax credit program to encourage the preservation and rehabilitation of historic properties for community use.[3] Finally, the New Jersey Historic Trust provides preservation grants to public and private nonprofit organizations. I urge readers who live in areas with historic structures in need of preservation to look into these programs and get in touch with the New Jersey Historic Preservation Office, the New Jersey Historic Trust, and Preservation New Jersey.

I first became interested in abandoned places after reading about the Essex County Overbrook Hospital in Cedar Grove in the book *Weird NJ*. Absolutely intrigued by my initial exposure to these forgotten spaces, I gathered some friends to go with me during my junior year of high school to see the old hospital. We went on several occasions, the first few just to look at the outside. Then I started to wonder what was inside. Eventually a few of us went in and were amazed by what we saw: medical records and patient files left behind, old beds, and furniture rotting away. This was a whole new, incredible experience. I went home and showed my parents the cellphone photos of what we'd seen, and they were shocked and curious. They were also very concerned because it was a tremendously unsafe environment. They told me not to go back, but I did on several more occasions, taking cellphone photos and simply enjoying the history.

Several months later, as I was entering my senior year, I learned that the old psych center would be torn down for development. I was upset that its history would be erased and there wasn't much to show beyond an episode of *Ghost Adventures* and some poorly produced YouTube videos claiming the asylum was haunted. I felt compelled to preserve the authentic history in some way.

Then, while taking a high school film class, I decided to produce a short documentary about the hospital through interviews and video. I reached out to the

historical society in Cedar Grove and several residents of the town and interviewed them about their experience of living in a town with a psychiatric center. I also contacted the developers to see if they might let me on the property to capture some video of the outside of the buildings. They agreed, and I went with my dad and a film teacher, Scott Gallagher, who helped me gather video. My father, Paul Nadler, took the photos of Overbrook you see in this book, while I shot video. The project turned into an eighteen-minute short documentary that I screened in Cedar Grove, at a few local film festivals, and at the Jersey City International TV and Film Festival (watch the video at www.youtube.com/watch?v=5VNd5aZVSho).

The Overbrook film led me to dive deeper into photography because I wanted to improve my compositions and capture photos in addition to video. Through my college years, I continued traveling to hundreds more abandoned buildings, photographing them, and sharing the pictures with my photography classes at Goucher College, where I was a communications major and a historic preservation minor. A big moment for me in college was when I entered a photo of an abandoned church in an art show and the president of the college and his wife bought the picture. At the Glasgow School of Art, where I studied photography for a semester, my instructors and peers critiqued my work and encouraged my passion for documenting abandoned places. They pushed me to contextualize and incorporate the greater meaning of the work.

Since graduating from college, I've continued my architectural and abandoned building work and have been able to use that skill for my current profession as a real estate photographer. Today I take pictures and videos of houses every day for work, using the skill set I learned by capturing images of abandoned buildings all through college.

Ever since I began photographing abandoned buildings, I have pushed to create the highest quality images I could. My goal is to highlight the architectural features as well as the functions of the historic spaces I'm in. I use professional photographic gear and strive to achieve the highest technical and artistic standards of architectural photography.

1

HOMES

Have you ever driven past a beautiful, overgrown, abandoned house and wondered about its story? Homes like this, hidden in plain sight, are all over New Jersey. Some go back as far as the eighteenth century, some are in better condition than others, and some even contain original furnishings. A deep sense of wonder surrounds them all. Who lived here? What happened to them? Why is the home no longer lived in?

I find these houses mostly while driving backroads. Rather than just reflect before moving past on the little triumphs and tragedies that may have occurred within their walls, I want to learn their stories, what happened, and what's been left within those walls. Otherwise, we might never know what has been forgotten.

Abandoned structures are fascinating because the "abandoned state" of a place is only one piece of the building's history. It's a period where the place has been neglected, and either it will fall down on its own, be torn down intentionally, or preserved as people see the value in the building and want to restore it to its original use or a new one.

To me, respectfully exploring and assembling photographic records of these homes is vitally important because neighbors, civic leaders, and historians should know their beauty and stories. In some cases, the history of a home may be so compelling that individuals or even whole communities find it worth the effort to embark on restoration projects.

To give just one example, on a recent real estate photography assignment, I was sent to an abandoned home. The windows were all blown out, parts of the ceiling were hanging down, the porch was caving in, and I wondered whether I had been sent to the wrong address. I soon learned that this was the correct place, and that

the owners, who were planning to rehabilitate and renovate it, wanted "before" pictures for their records.

So many homes in foreclosure sit vacant for years with no apparent future, but some are brought back. Two homes I discovered in the spring of 2020 in Central New Jersey that I had simply driven by had notices of abandonment, so I kept an eye on them over a few months. By the fall, families had moved in and the buildings looked like new. It's gratifying to see buildings saved and brought back to life.

GLEN ALPIN

Of the many abandoned homes in New Jersey, a few especially capture the imagination. Among the most notable is Glen Alpin, built in 1847 in Morris County's Harding Township. As described by Preservation New Jersey, one of the state's leading historic preservation advocacy groups, Glen Alpin is "a 22-room, 14,000-square-foot mansion, [that] has been called one of the finest examples of Gothic Revival style architecture in New Jersey."[4]

Before Glen Alpin's construction, the property was the site of a 1,250-acre farm known as Mount Kemble. It was established in the 1750s by Peter Kemble, a longtime member and one-time president of the royal council governing the English colony of New Jersey. During the Revolutionary War, Mount Kemble was used for a time as George Washington's headquarters and a Continental Army encampment. The property is almost adjacent to Jockey Hollow, which housed the entire Continental Army during the harshest winter of the war, from December 1779 to June 1780.[5]

A succession of new owners began in the 1960s. Recognizing the historic value of the property, Harding Township and the Harding Land Trust purchased Glen Alpin in October 2004. It has since been left vacant and over the years has sustained some damage.[6] Recently, efforts to secure it have been made. The building is now boarded and there are notices of cameras around the property in addition to a stronger police presence in the area. As of 2017, the town was exploring putting the property up for auction, but as of July 2021, the property still sits unused.

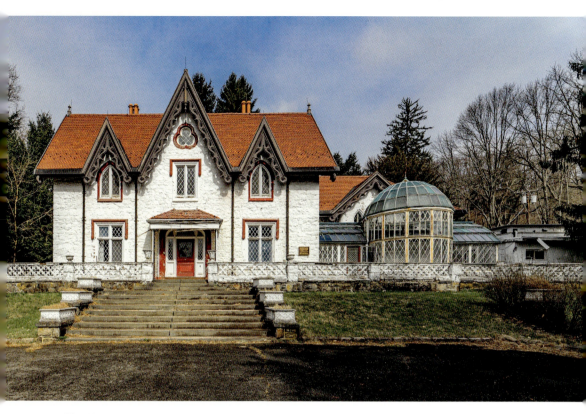

Glen Alpin is a Gothic Revival-style mansion built in 1847.

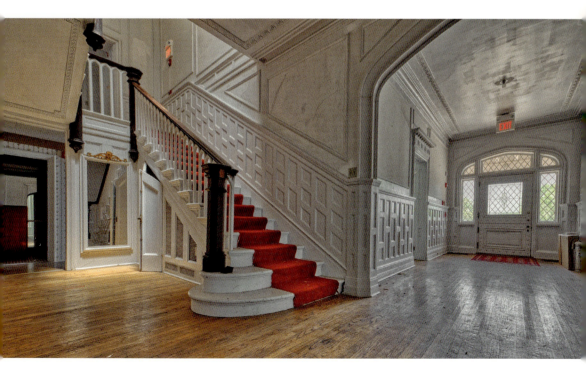

The entrance leads to an elegant main stairway.

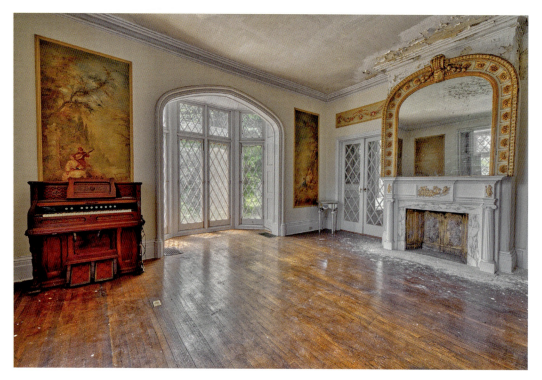

This front room features beautiful detail work around the fireplace and the mirror above it. Note the antique keyboard instrument.

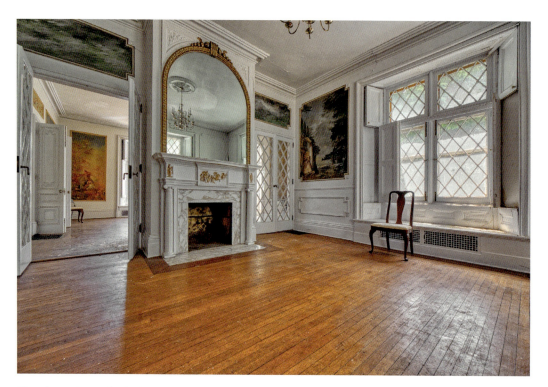

Glass doors connect the front room to an adjacent one.

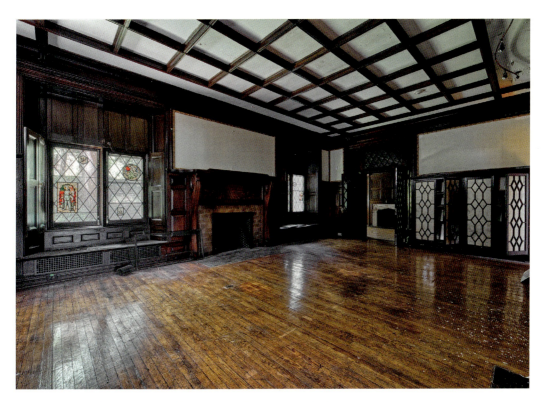

The stained-glass panels in the windows include images of Saint George.

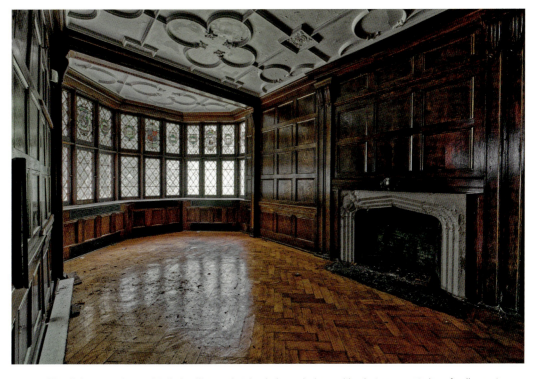

The dining room has a detailed ceiling and stained-glass windows with what appears to be a family crest.

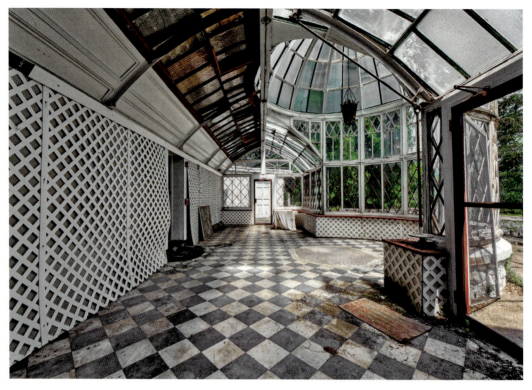

This unique glass conservatory was added in 1886.

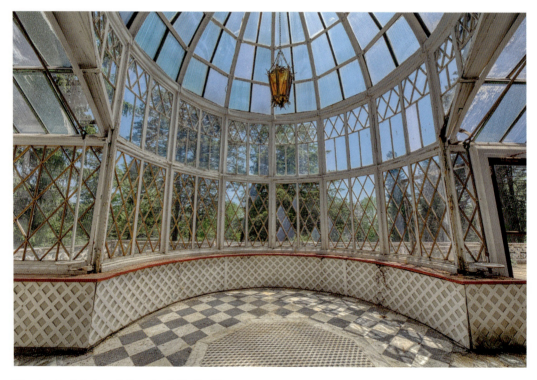

The conservatory dome looks out onto the front terrace.

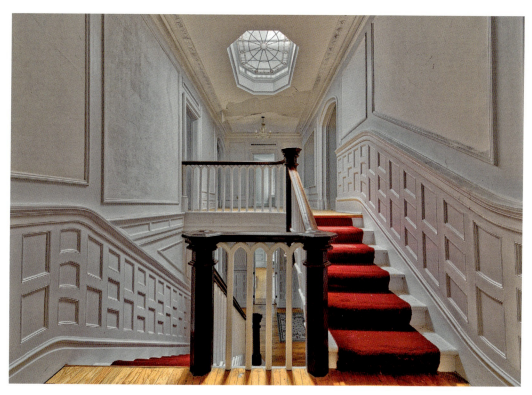

The grand staircase leads to the upstairs hallway and bedrooms. Note the elegant skylight and molding.

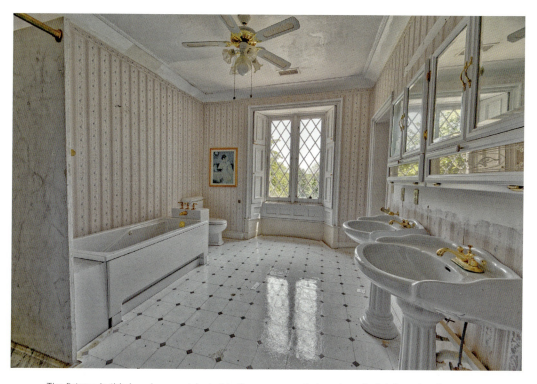

The fixtures in this luxurious upstairs hall bathroom appear to have been tastefully updated.

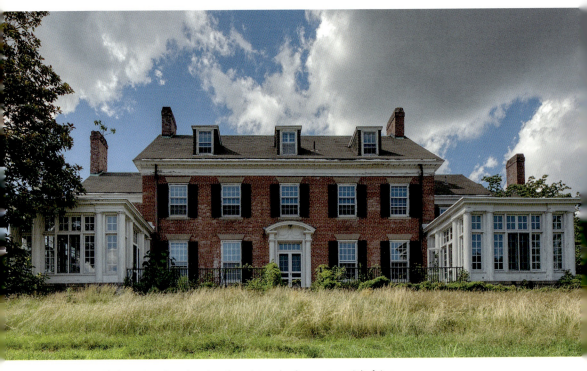

An early twentieth-century Georgian abandoned mansion has an uncertain future.

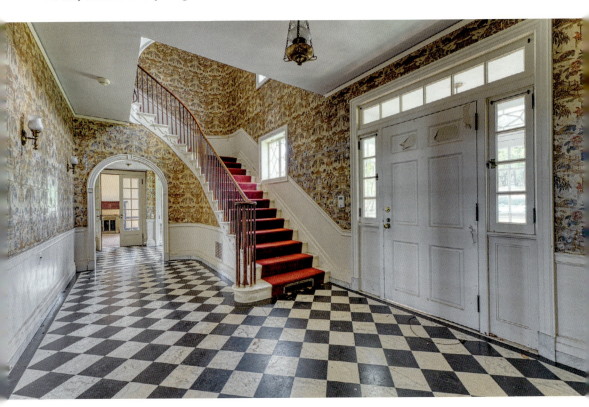

The front entryway has a black-and-white tile floor and Asian-themed wallpaper lining the center hallways.

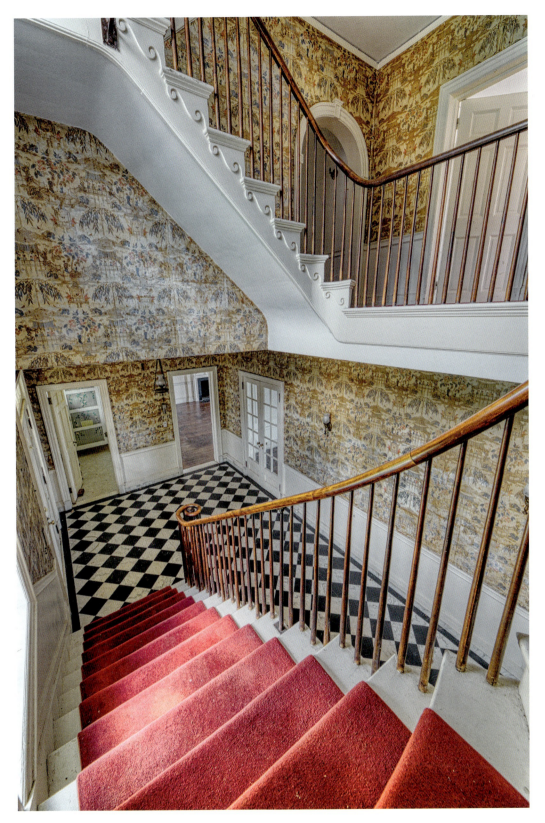

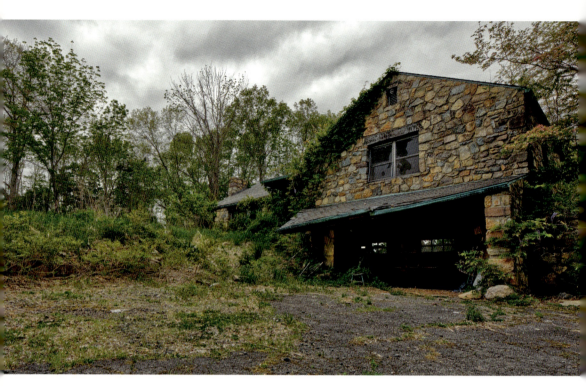

This rustic western New Jersey home, built in 1951, was overtaken by nature and has since been demolished.

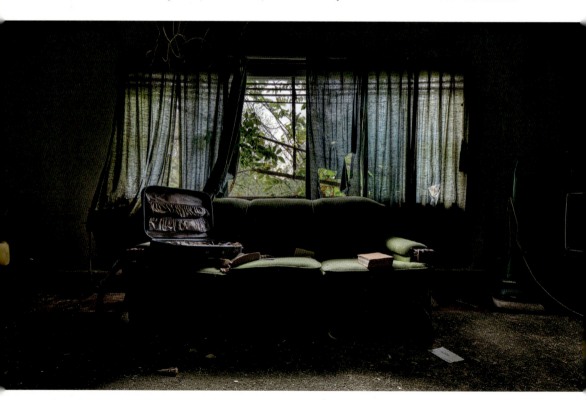

This decaying living room is filled with personal belongings left behind.

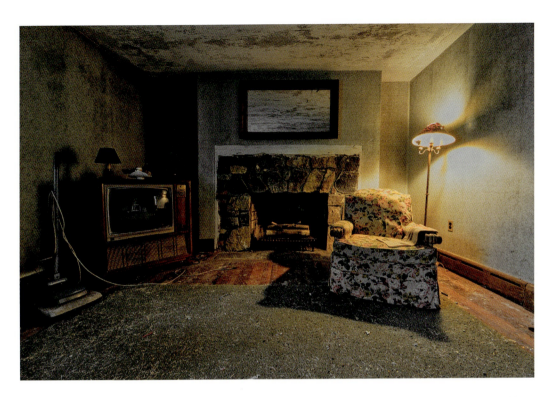

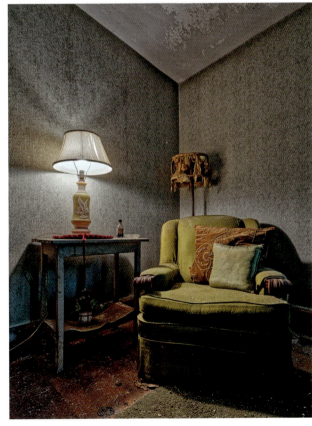

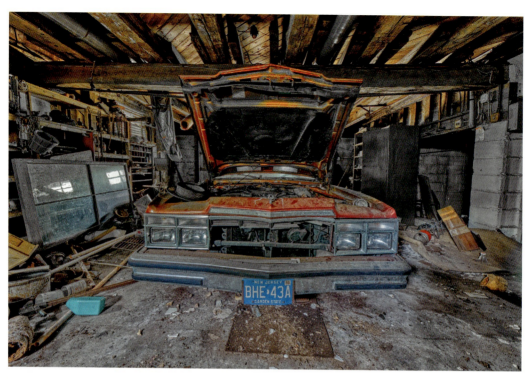

An old Chrysler rusts in the garage.

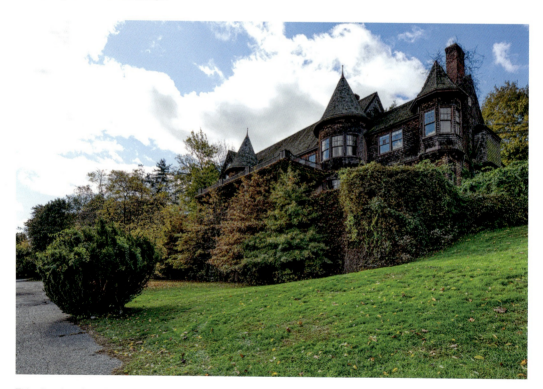

This abandoned northern New Jersey mansion, built as a replica of a Norman castle, sits on what was once a 261-acre estate. Despite its deteriorating condition, there have been recent community efforts to save it.

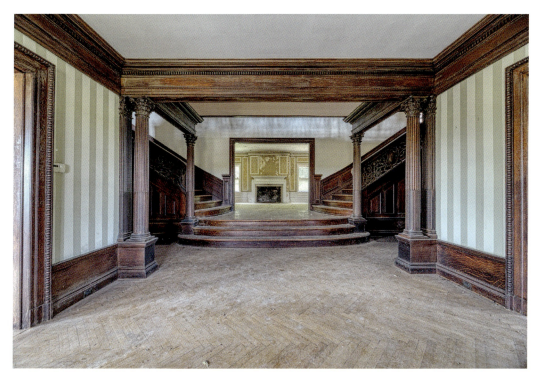

The mansion's main entryway features detailed woodwork.

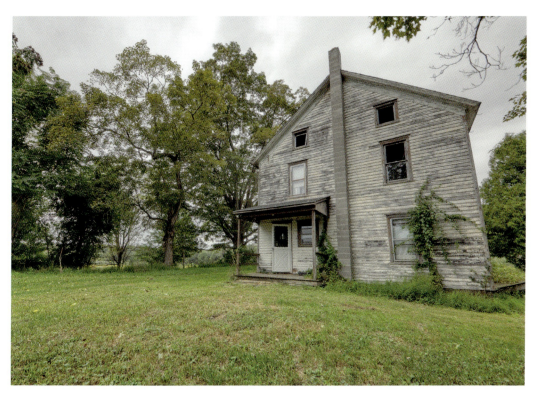

A typical western New Jersey farmhouse.

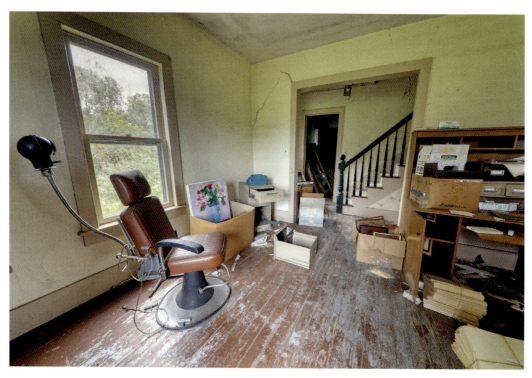

The house's interior has a former professional office with an examining chair.

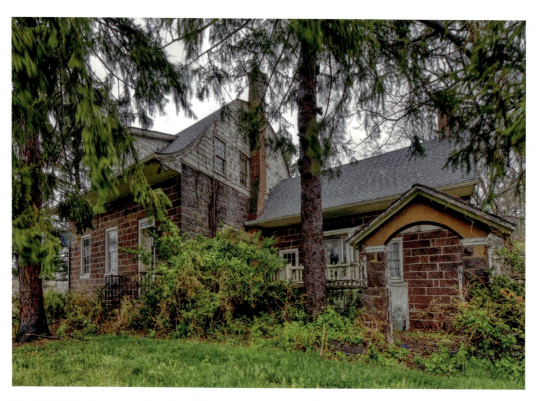

This Dutch Colonial-style home in northern New Jersey was built in 1826.

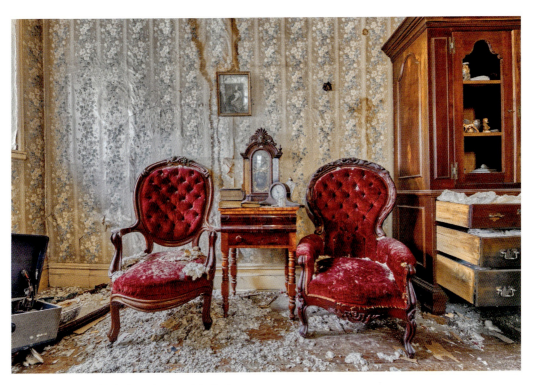

Two chairs slowly decay in an upstairs bedroom.

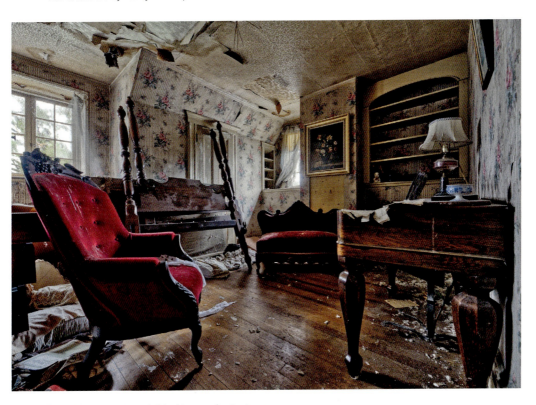

Furnishings have been left inside a corner bedroom.

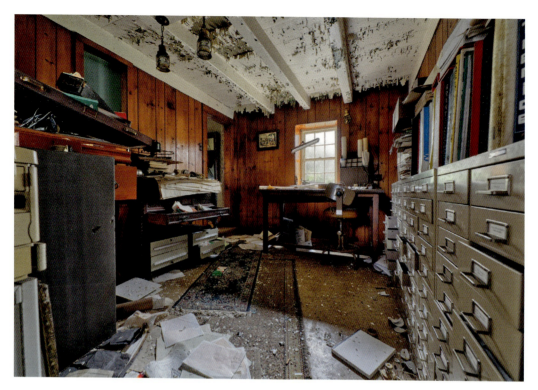

This ground-floor office may have belonged to an architect or builder.

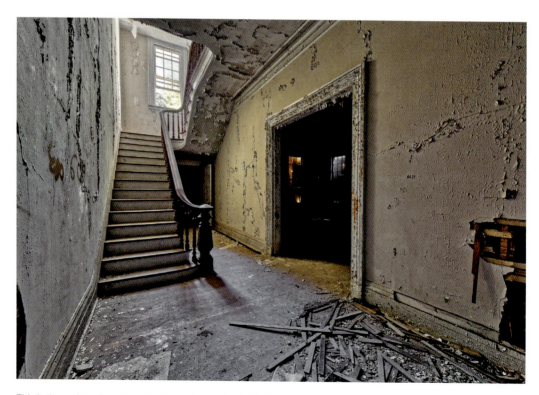

This is the main staircase of a large 1800s mansion in Central New Jersey.

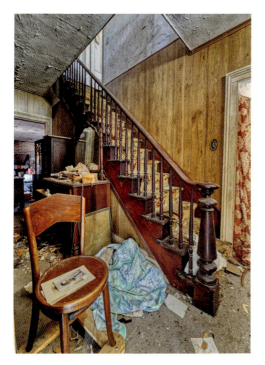

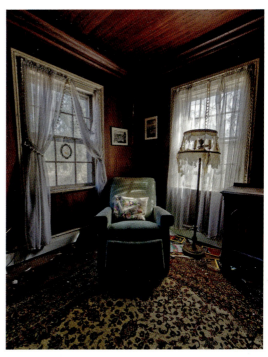

Above left: The center hallway of this western New Jersey farmhouse is full of furniture and personal belongings.

Above right: A chair and a deteriorated antique lamp are left in the living room.

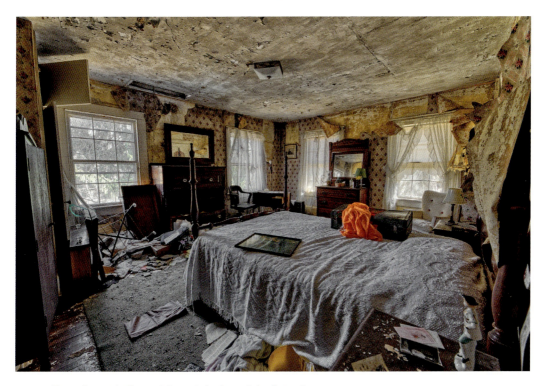

The wallpaper in the upstairs main bedroom is badly peeling.

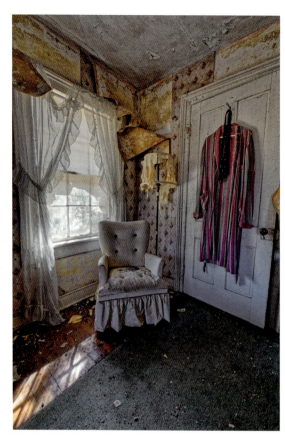

Left: Mold and mouse droppings litter this chair.

Below: Mold is overtaking the ceiling of this 1950s ranch house.

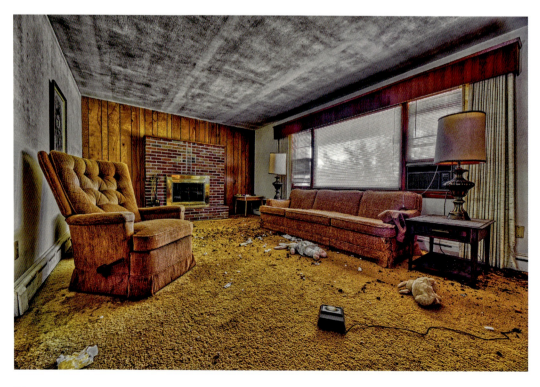

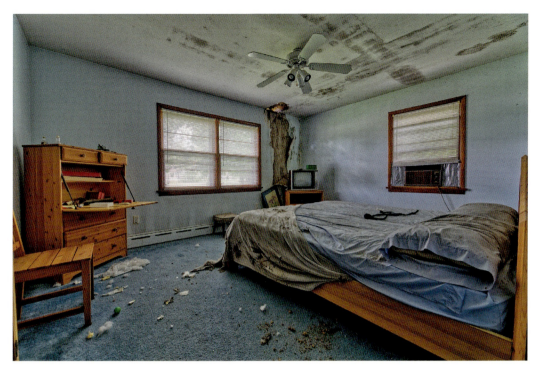

The hole in the ceiling at the far corner has led to extensive water damage and hastened the decay.

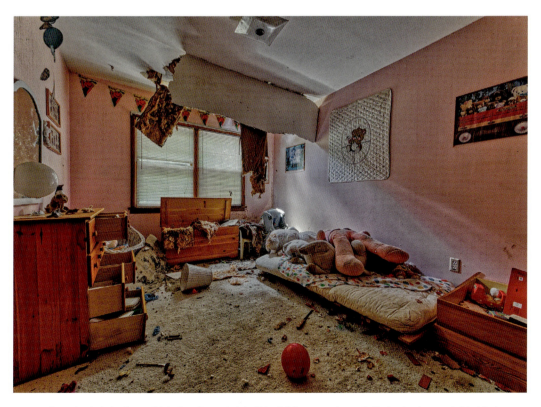

A gaping hole in the roof lets the elements into this child's room where stuffed animals were left behind.

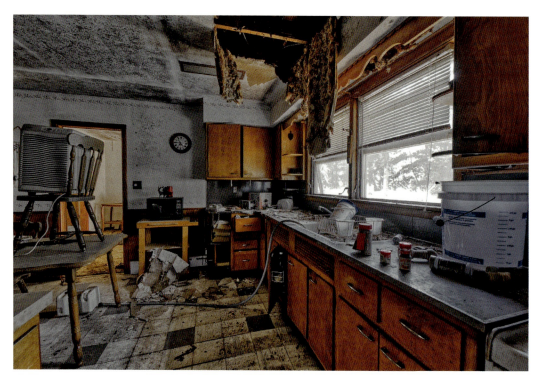

Signs of a futile effort to clean up can be seen in this deteriorating kitchen.

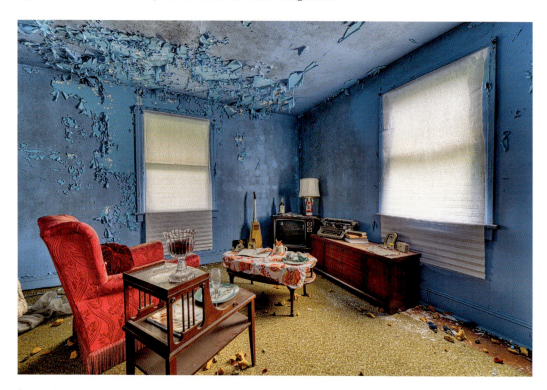

Some urban explorers consider it art to rearrange items in these old places to create a new scene—one example is this clearly staged living room of a decaying farmhouse. I prefer to document spaces as I find them.

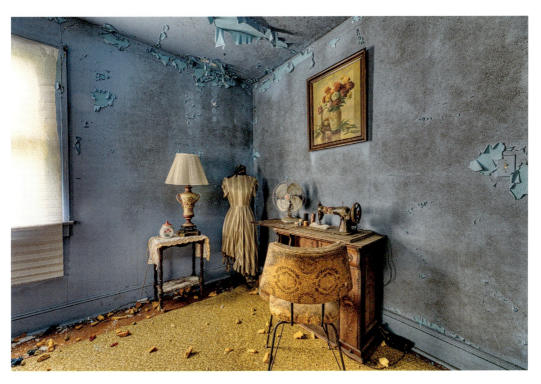

A vintage sewing machine has been left intact next to an old dress form.

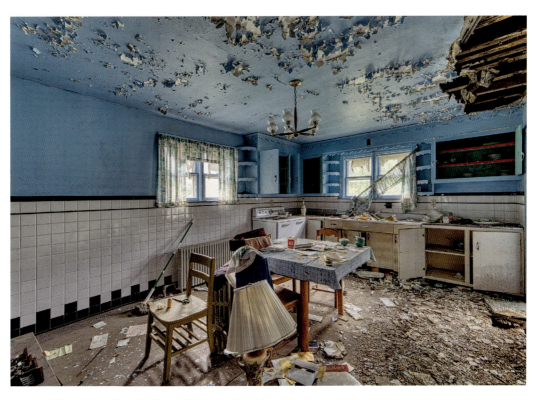

Ceiling plaster litters the floor of this crumbing kitchen.

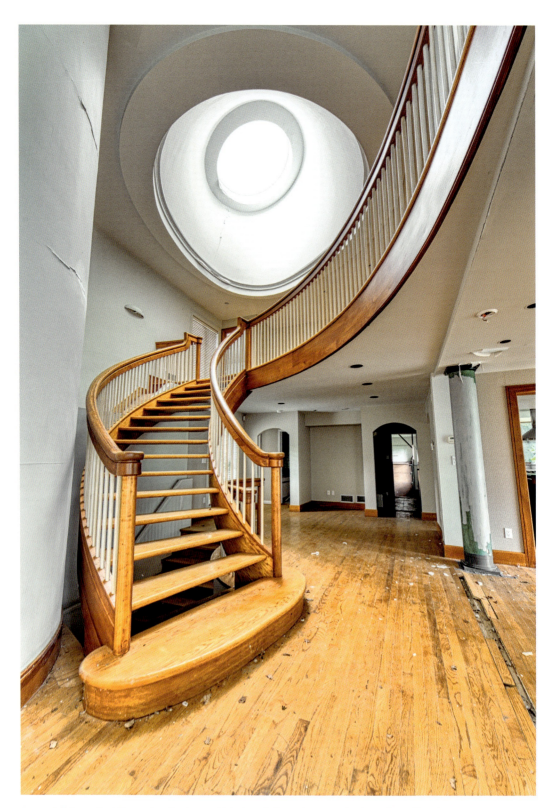

A grand staircase is at the center of a decayed late-twentieth century mansion in northern New Jersey.

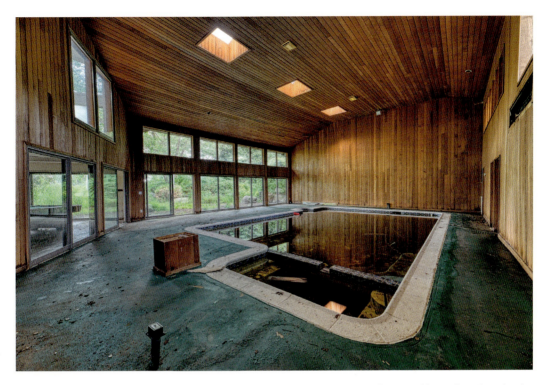

Broken windows have exposed the building to the elements—you can hear frogs croaking and see them leaping out of the pool.

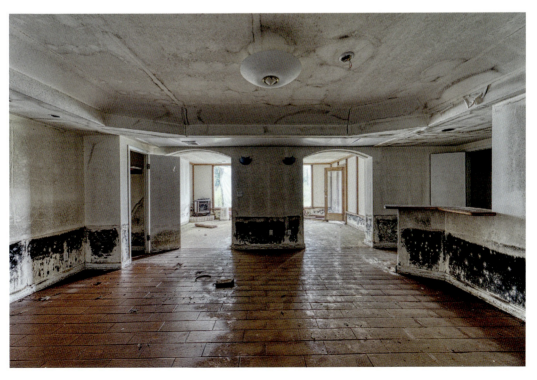

Black mold covers the lower half of the walls of a room down the hall from the pool.

2

ENTERTAINMENT

D id you know that movies were born in New Jersey? Hollywood usually comes to our minds first, but New Jersey is where film technology was created and where the motion picture industry began.

- Nitrocellulose film was patented in 1887 by Newark inventor Hannibal Goodwin.
- William Kennedy Laurie Dickson, a researcher in Thomas Edison's West Orange laboratory, invented the kinetograph and the kinetoscope, the first movie camera and film viewer.
- The first movie studio was built in Fort Lee in 1909.[7, 8]

From the 1890s to the 1930s, vaudeville was popular. This series of unrelated live variety acts on a single bill could be performed in standard live theaters and persisted until "talkies"—films with synchronized sound—were introduced in the late 1920s. Early movie theaters, often called "nickelodeons" (or five-cent theaters), were constructed from small, converted storefronts and were in use from about 1905 to 1915. Then, beginning about 1920, new "movie palaces" were built as grand and ornate film venues that resembled the auditoriums of traditional theaters but replaced the backstage area with a film screen. These extravagant centers of art and community offered everyday citizens a taste of luxury and remained popular at least until the television era began in the 1950s.

Many entertainment venues across New Jersey—theaters and movie palaces, along with hotels and other major entertainment hubs—have been demolished or are crumbling. Why? Today we live in a culture dominated by personal entertainment systems: television, mobile devices, the internet, and portable projectors for our homes.

Many of our entertainment and social centers such as shopping malls are being neglected. Closures due to the Covid-19 pandemic have only accelerated this decline.

It's an eerie experience walking into the dark abyss of an abandoned movie palace. These massive places were once cornerstones of the community, places people came out to on the weekend with their families and friends. The air is so still, dusty, and the building echoes as you wander through it. I find it amazing, terrifying, and beautiful all at once. I wonder what it was like when a theater was thriving, why it all ended, and whether anything can be done to preserve it. I'm fully engaged in what I'm doing at that very moment as I explore and document, for my own sake but hopefully to allow others to see what once was. I photograph these places not only to share what I see but also as a way to try to capture the feelings I have while there.

Hotels and other places of hospitality also sit on the wayside, often because their locations are no longer bustling. On my many drives I've discovered hidden relics like old diners that are just rotting away. I was speaking to a friend about one diner I visited, and she said, "Which one? I think I used to go there with my family back when I was a kid!" It's touching how people have connections to these lost places and I wonder if anything can be done to bring them back or to repurpose them.

THE PARAMOUNT THEATER

The Paramount Theater in Newark is a prime example of a movie palace that has been lying derelict for so long that it seems a disaster waiting to happen. I was eager to view this beautiful place, but I was also intensely concerned for my own well-being. I could barely see with the light of my phone and the entire ground floor was a sea of trash, making every step precarious.

The building first opened as H. C. Miner's Newark Theatre, on Oct. 11, 1886.[9] A live theater and vaudeville house located on Market Street in the then-bustling Four Corners neighborhood, it was managed by Hyde & Behman Amusement Co., a Brooklyn-based theater management company. Following Miner's death in 1900, his family sold the property in 1916 to Edward Spiegel, the owner of the nearby Strand Theatre.[10] To update the aging house, Spiegel hired noted theater architect Thomas W. Lamb, who replaced the wooden balconies with a single concrete and steel balcony and expanded the capacity to 2,000 seats. Then, in 1932, with the Great Depression in full swing and vaudeville in decline, Paramount-Publix (now Paramount Pictures) stepped in and remodeled the theater for movie showings. Renamed the Paramount, the structure operated as a movie house for more than half a century, finally closing for good on March 31, 1986, because of an increase in insurance rates.[11]

In 2012, the RGH development group received a $52 million grant from the state of New Jersey to help fund the Four Corners Millennium Project. The project calls for a mixed-use residential and commercial building to be built on the site of the theater. There are plans to incorporate the facade into the new building while demolishing the auditorium.[12] But as of this writing, the theater remains abandoned.

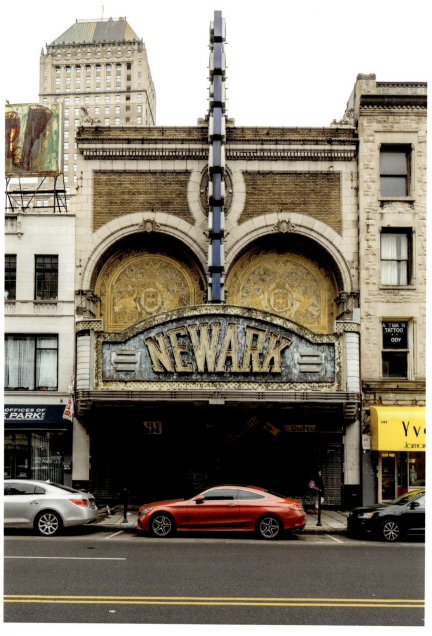

The Paramount Theater's facade is a landmark of downtown Newark.

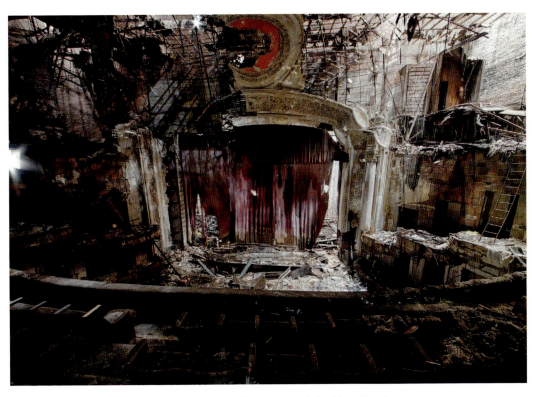

From the balcony you can see the remains of box seats on both sides of the stage.

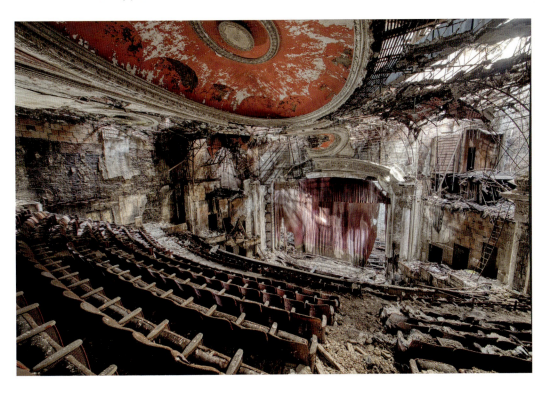

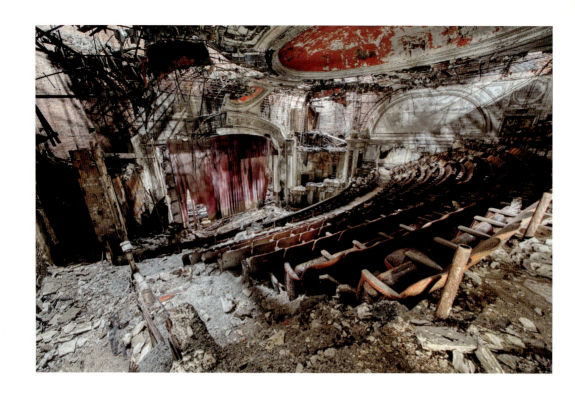

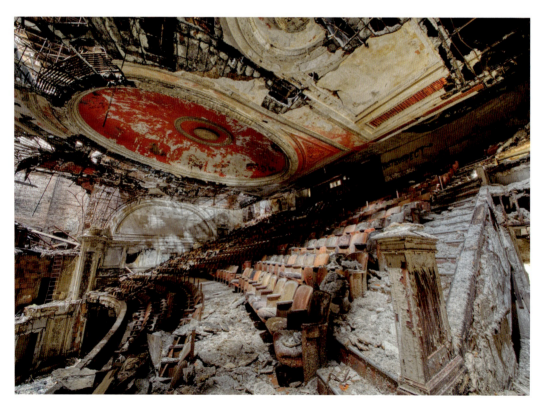

Looking up from the front of the balcony, a patron would have seen rows of seats and a beautifully decorated ceiling.

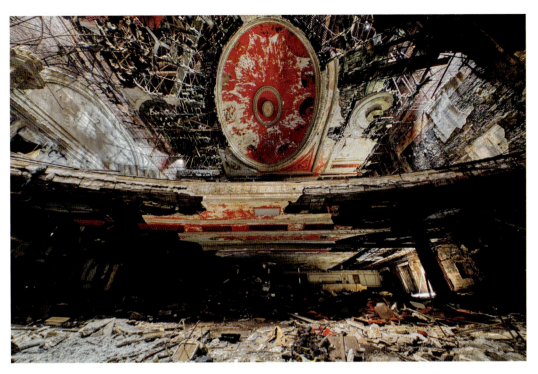

From the stage you can see the arc of the balcony and the ornate but now crumbling ceiling.

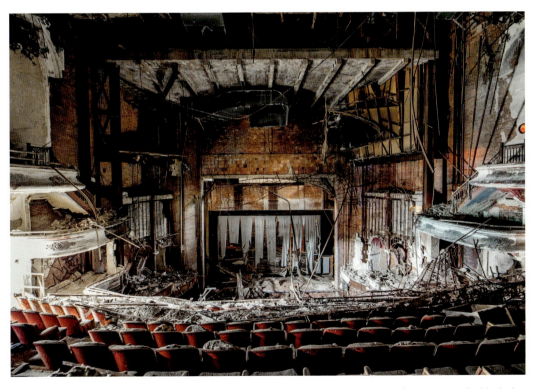

Another disintegrating vaudeville-era theater in Newark was later converted for film. This was a rare double-decker venue with a large downstairs theater and a smaller, separate one upstairs.

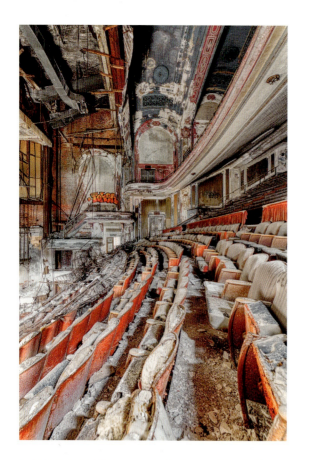

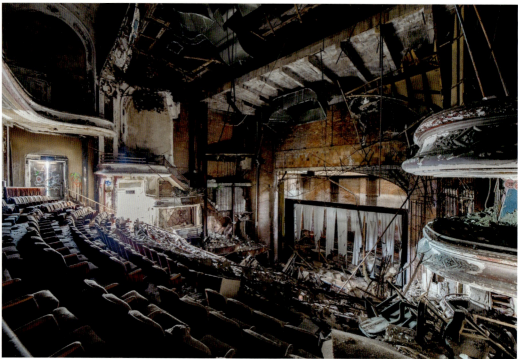

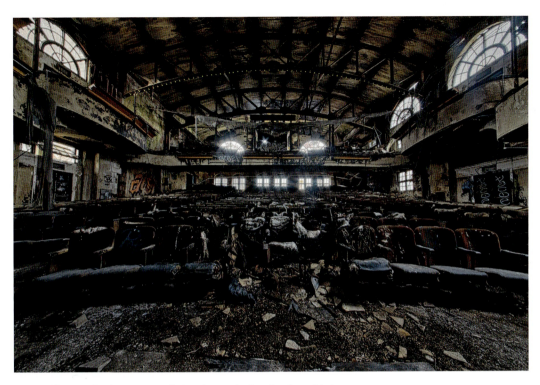

The upstairs theater space featured an arched roof and small balcony.

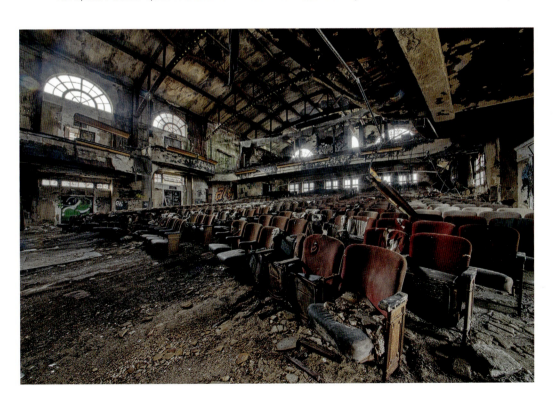

CENTRAL NEW JERSEY MULTIPLEX CINEMA

Also notable is a multiplex cinema in Central New Jersey. It operated originally as a drive-in theater—a neighbor of mine recalls hiding extra people in her car to see *Grease* there—which was replaced with a multiplex in 1979. It closed Memorial Day weekend of 2005 because of a "sinking floor." The building is situated next to marshland.[13] The theater never reopened and has been vacant ever since.

Walking through this complex was a fascinating experience because the interior is pitch-black aside from two end theaters where light filters in from the decaying ceiling. There was little graffiti within, which is unusual. Many places in such trafficked areas tend to be heavily vandalized because they're so visible. Perhaps the darkness has been a deterrent for vandals or graffiti artists because no one will see what they've done or they themselves can't see anything when inside. I have vague memories of going to a movie at this theater as a child with my family, so it was surreal to document it fifteen or more years later. It's a shame we've left the site in poor condition when there could be an opportunity to restore the marshland.

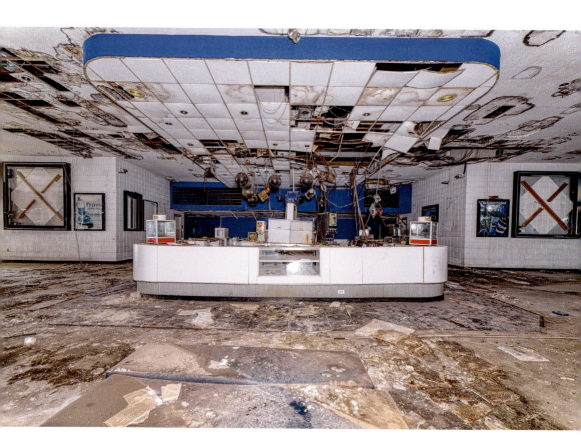

Popcorn and soda machines still remain at the central concession stand of this 1970s-era multiplex.

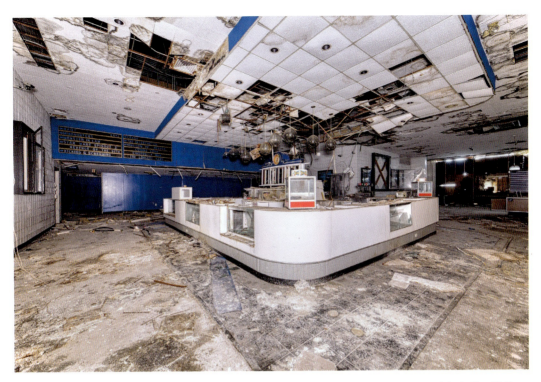

The marquee on the left lists some of the movies showing in 2005 when the theater closed, including *Mothers-in-Law* starring Jane Fonda and Jennifer Lopez.

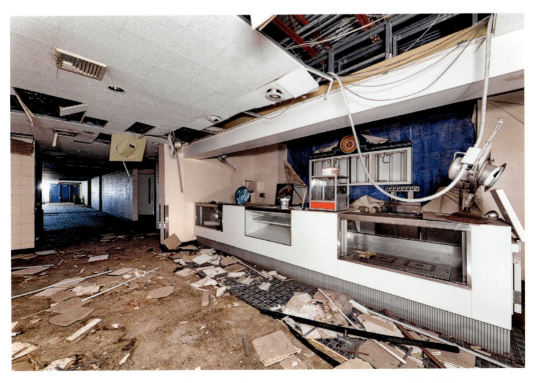

A popcorn bucket branded for *Shrek 2* remains on the counter of a hallway concession stand.

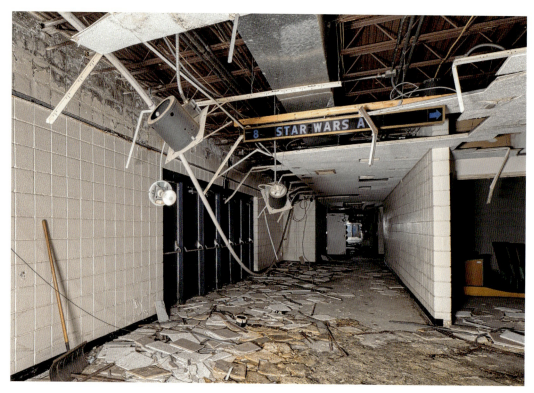

When the fourteen-screen complex closed, theater eight was playing *Star Wars: Revenge of the Sith*.

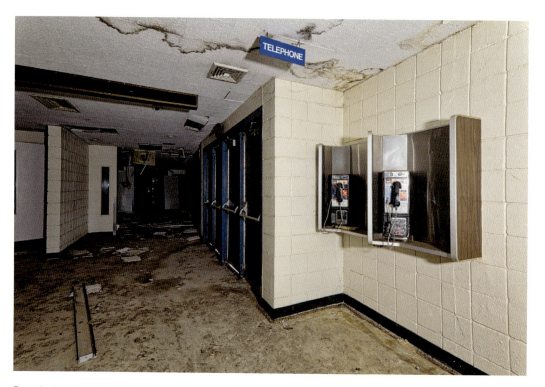

Pay telephones, signs of another era, remain near the exits.

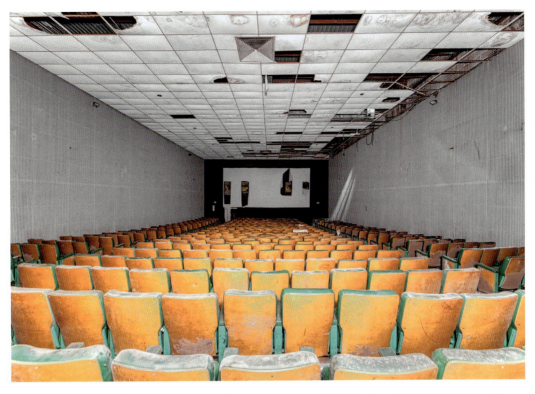

The theaters in this multiplex are long and narrow to accommodate the rectangular footprint of the building.

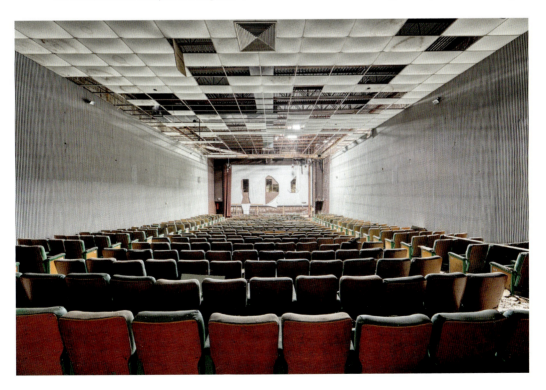

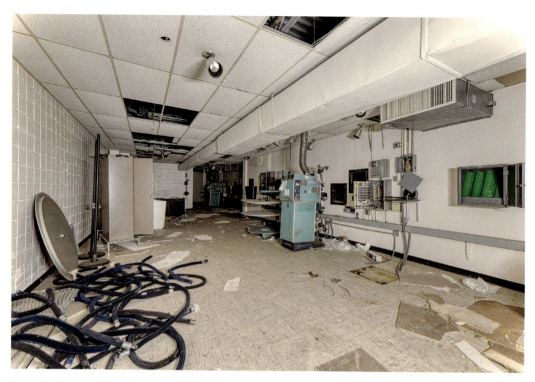

The projection area spans the backs of all the theaters, which are side by side. Notice the 35-mm projectors, now almost obsolete.

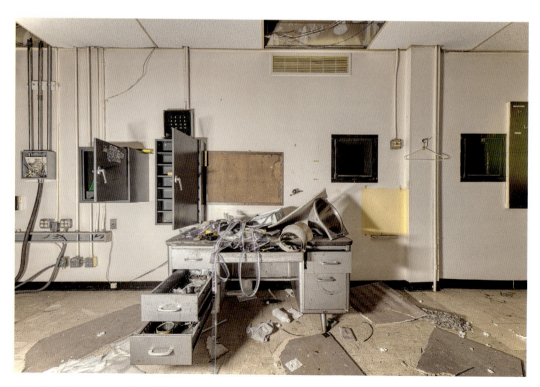

Snippets of 35-mm leader film still lay atop a desk in the projection room.

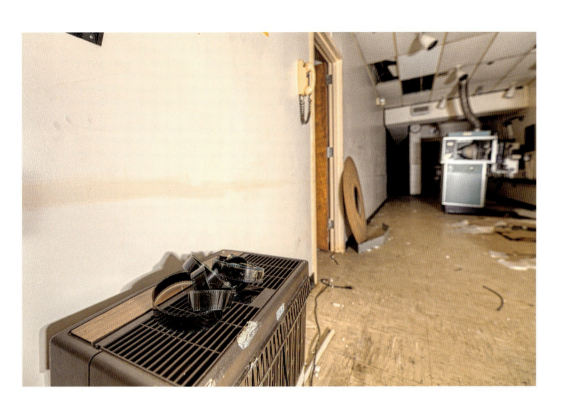

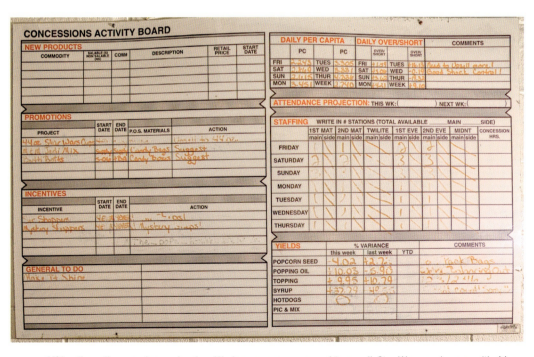

Lifting the veil on movie snack sales: Workers were encouraged to upsell *Star Wars* moviegoers with 44-oz. drinks and the M&M Jedi mix.

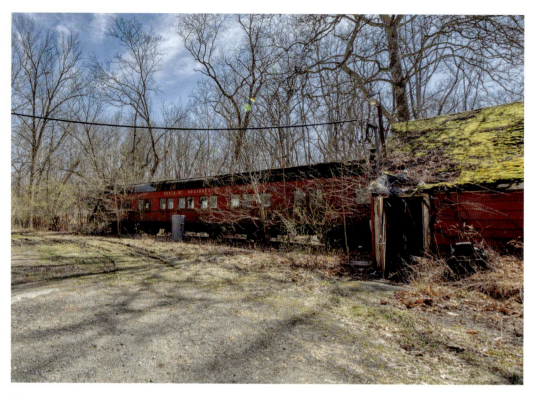

This abandoned restaurant includes a repurposed railroad dining car.

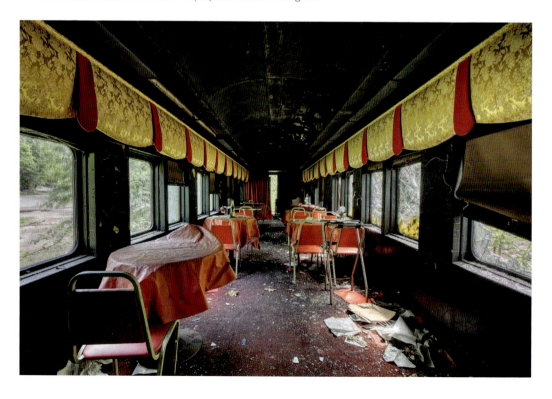

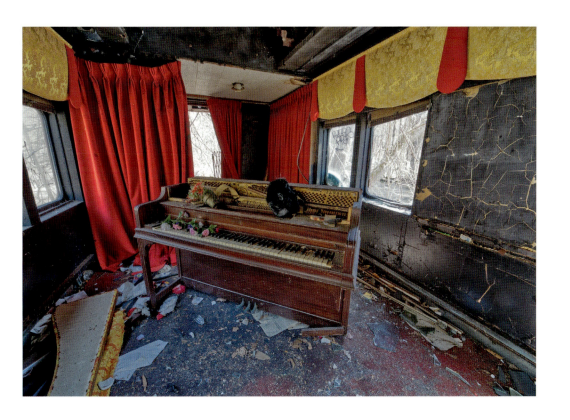

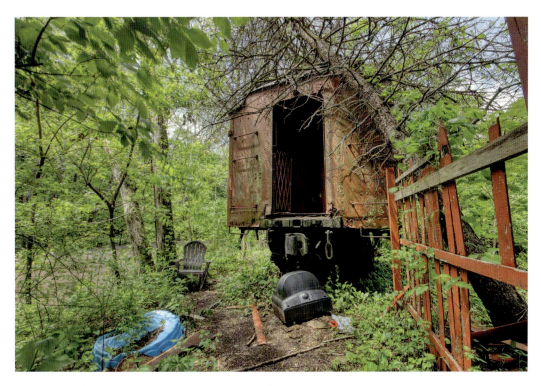

Sadly, the area outside the train car has been treated as a garbage dump.

This classic New Jersey diner almost looks ready to welcome customers.

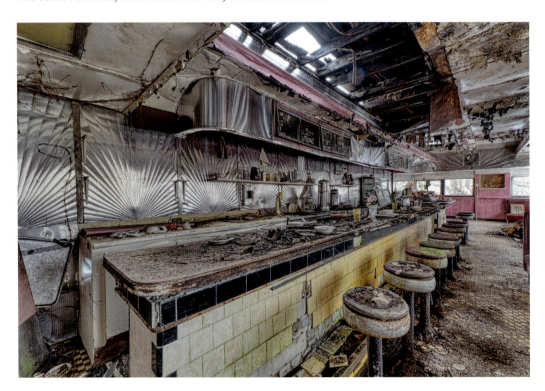

Amid the debris from the collapsed ceiling, the counter area still has coffee machines, glasses, and bowls left behind.

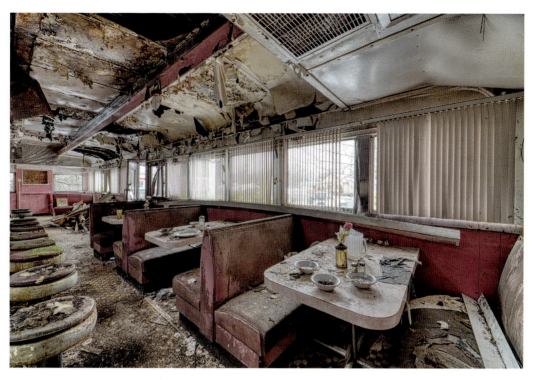

Booths with bowls and salt and pepper shakers still line the front windows.

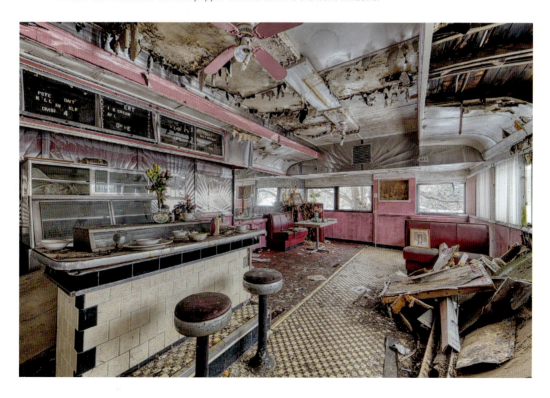

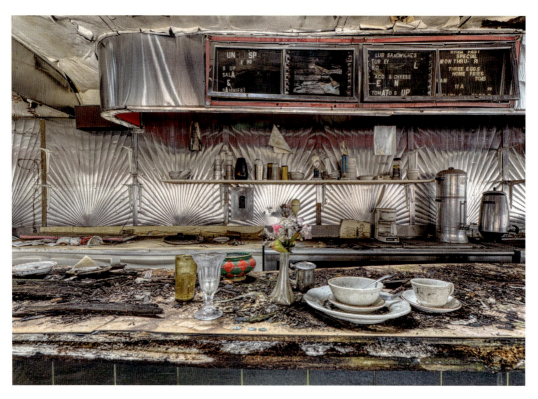

The sign above the counter includes the breakfast special: three eggs, home fries, and toast.

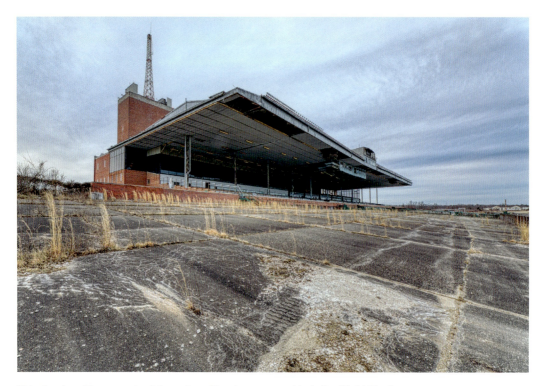

This abandoned horse racetrack in southern New Jersey opened just after World War II.

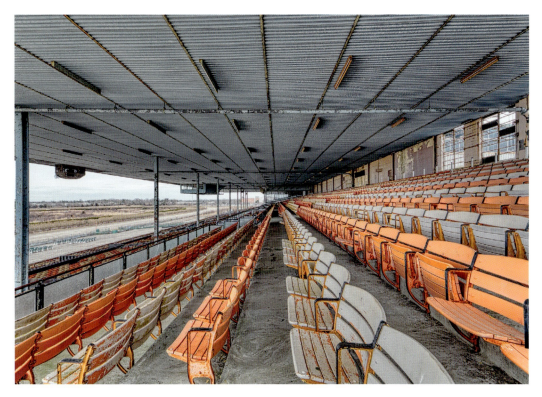

Seats in the viewing area appear to be in surprisingly good condition.

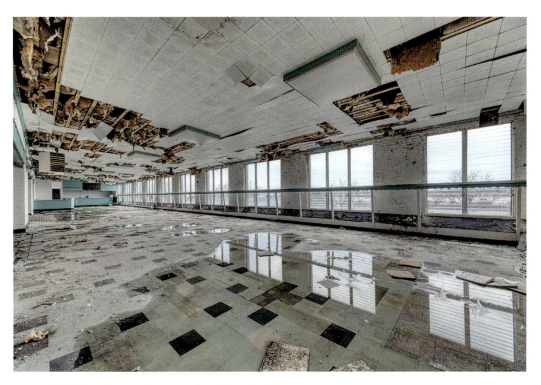

The food service area faces away from the racetrack.

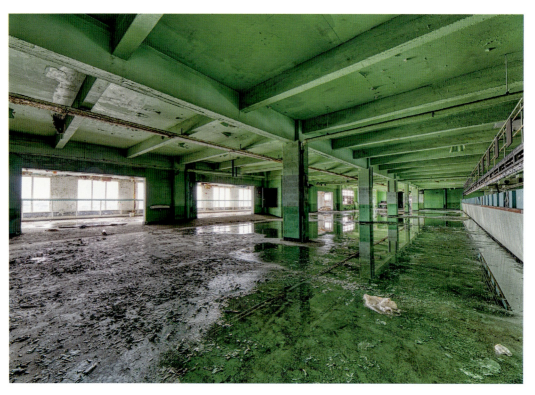

This space with extensive water damage includes betting windows on the right.

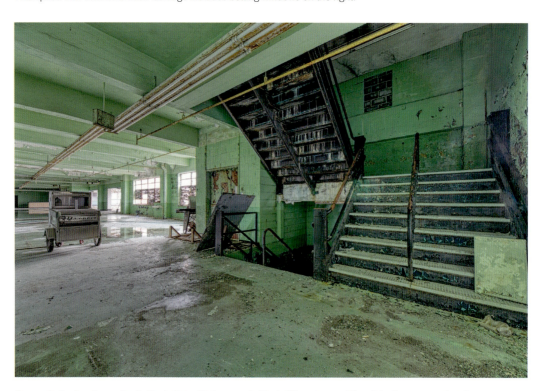

An empty food cart remains in the hallway that connects the betting area and the stairs to an upper level.

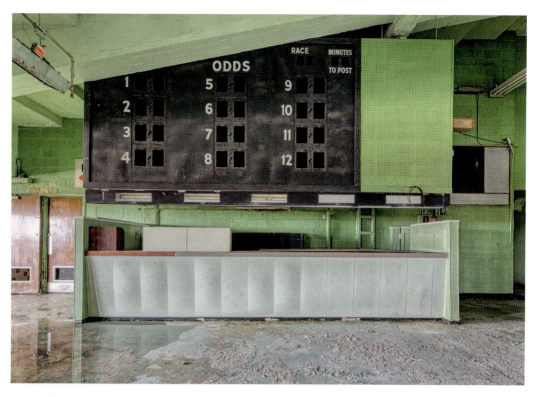

The tote board displays potential payouts for different bets.

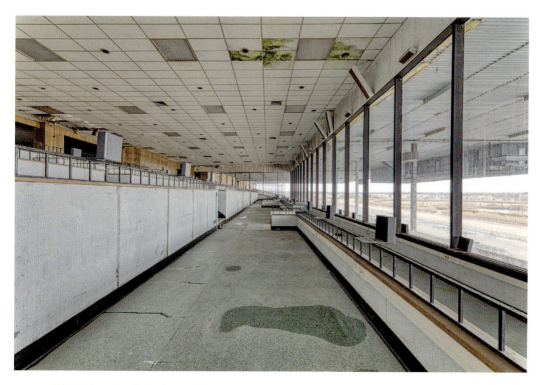

Water is damaging the indoor viewing area.

3

PSYCHIATRIC AND TUBERCULOSIS HOSPITALS

At one time, state hospitals and private psychiatric institutions were the foundation of the American mental health system. During the first half of the twentieth century, they were the primary places where patients with mental illness and those who required long-term care were treated. Within the past fifty to sixty years, however, many of these hospitals and institutions have closed as drugs to treat mental illness have become more available and the process of deinstitutionalization has rapidly emptied their beds.

In the 1850s, only a small number of private and public mental hospitals existed in the United States, and the conditions in them were poor. Dorothea Dix, a teacher and reformer of the time, was a major figure in the field of mental health and an advocate for the improvement of conditions for patients and inmates in institutions. She made great changes in the world of mental institutions, creating and promoting ideals to enhance the operation of these facilities.[14]

ESSEX COUNTY OVERBROOK HOSPITAL

In New Jersey, Dix's ideas were put into practice in a number of institutions, including Overbrook, a large mental health facility situated in the small town of Cedar Grove in Essex County, and Hagedorn Psychiatric, a facility in Glen Gardner in Hunterdon County.

Overbrook Hospital was located on 325 acres designated by Essex County for the location of a hospital where the mentally ill could receive daily care in a beautiful setting. Construction of the hospital, which was just above the Peckman River, began in 1896.[15]

At its height in the early twentieth century, Overbrook housed more than 3,472 people and was commonly referred to as its own little city. It was so large that it had its own train stop on the Caldwell Branch of the Erie Railroad, which carried large amounts of coal and supplies needed to maintain the massive hospital. The complex consisted of an administration building, dormitories for the patients, a recreation center, dining halls, a chapel, and its own power station.

As with many American psychiatric hospitals, Overbrook's decline began in the mid-1950s when psychiatric medications such as Thorazine, the first effective antipsychotic medication, became available. The process of deinstitutionalization began around this time. This was the process of moving patients out of large state-run facilities to community-based care facilities. Unfortunately, in too many cases the community-based care was not properly funded, and some patients became homeless. Big institutions like Overbrook closed, and many of them still sit vacant today and are crumbling or have already been torn down. As patients left Overbrook, a new, smaller hospital was built next to the existing hospital center and the remaining patients were moved there. The original Essex County Hospital closed its doors in 2007.

Essex County had planned on selling the remaining portion of the property to real estate firm K. Hovnanian but tried to renegotiate the deal in 2008 in an effort to convert some of it into parkland. After a lengthy lawsuit, Hovnanian and Essex County reached an agreement in 2015.[16]

Throughout the lawsuit's eight years, the hospital was vacant, frequently trespassed upon and vandalized. This became a huge issue for the town of Cedar Grove as curious people traveled great distances to see the abandoned facility. The problem only grew because the hospital was featured on the TV show *Ghost Adventures*. The hospital had also been featured on several episodes of the *Sopranos* in earlier days shortly after it closed.

In 2016 the property was finally transferred to Hovnanian. Now there are town-homes on the plot of land where Overbrook was. The edges of the land are still owned by the county and have been transformed into a park and community center.

Today, a casual visitor might never know what was there because there are no markers or indications of the site's history. This is an example of what can happen to abandoned places. Sometimes historic buildings are just torn down and disappear without a trace. With the demolition of these buildings, a portion of a town's history is lost. It is incumbent on contemporary society to make sure that it's not lost. If we cannot save the buildings, we should be intentional about marking the site and documenting its history. In this way, at least part of the community's history, if not the buildings, can be preserved.

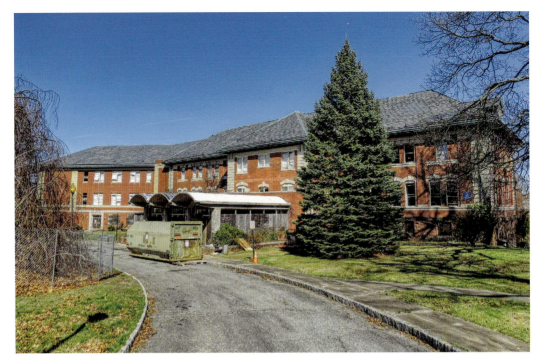

In 2015, a dumpster was placed in front of the Overbrook Hospital administration building before its demolition. Today, the site is a development of townhomes and there's no sign of the vast hospital campus. [*Overbrook photo credits: Paul Nadler*]

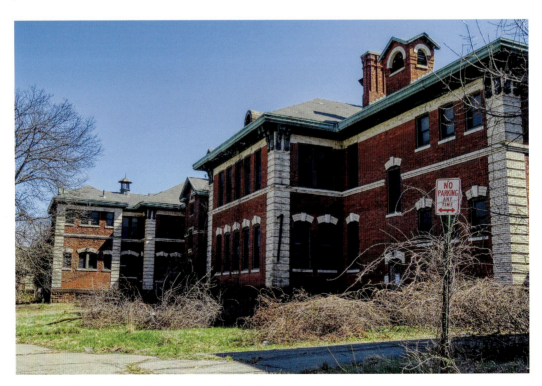

The residential building for male patients was on the north side of the campus.

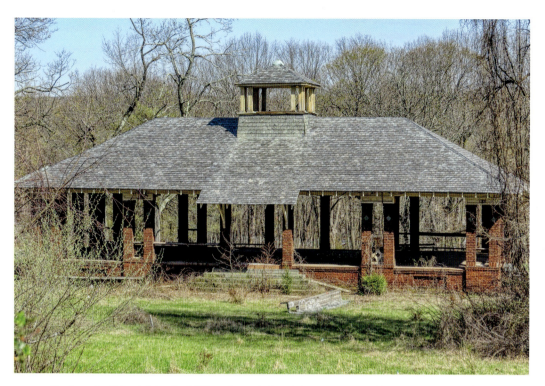

The large bandstand, down the hill from the main hospital wards, was used for performances and was open to patients walking around the campus.

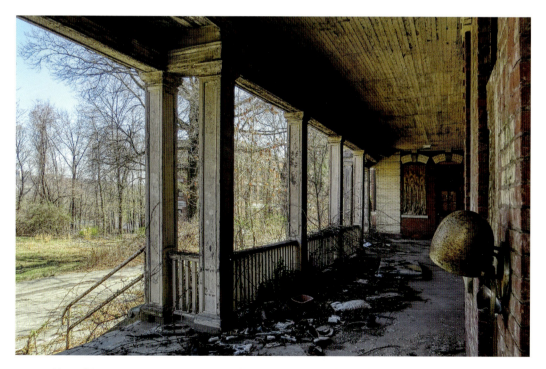

Many of the wards had porches facing south or east with a view of the hillside. This was one of the male wards with an eastern exposure.

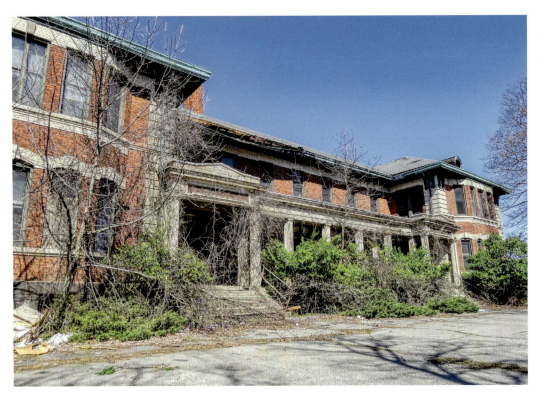

The porch of this male ward faced south.

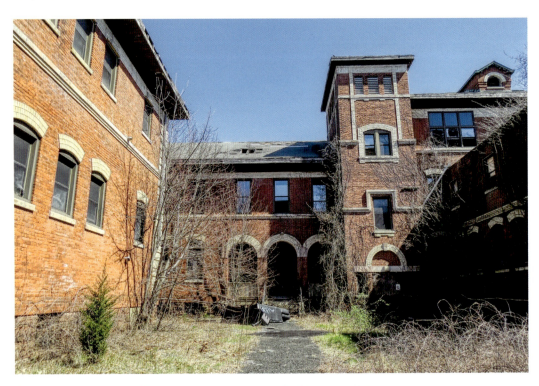

The rehabilitation building at the center of the complex connected the male and female sections.

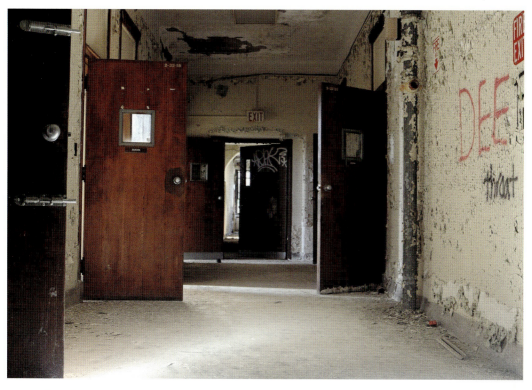

Ward hallways led to patient rooms. Note the outside locks on the nearest door in this female ward.

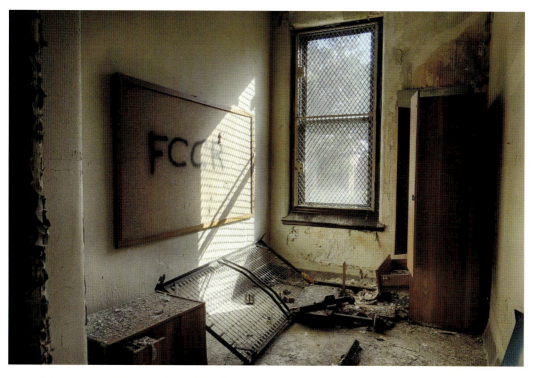

Furnishings and locked window grates still remained in many patient rooms.

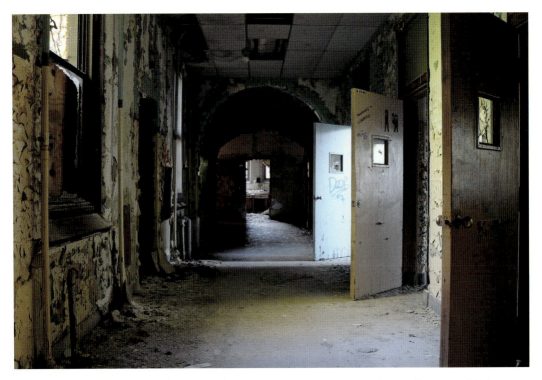

Paint peeled from the hallways of the rehabilitation building where patients worked on crafts as part of their occupational therapy.

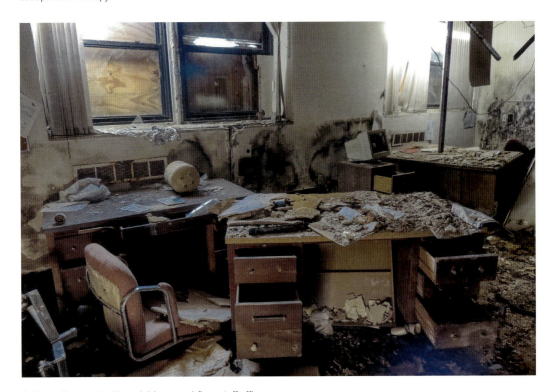

Fallen ceiling plaster littered this ground-floor staff office.

A bucolic scene was painted on the wall of one of the wards.

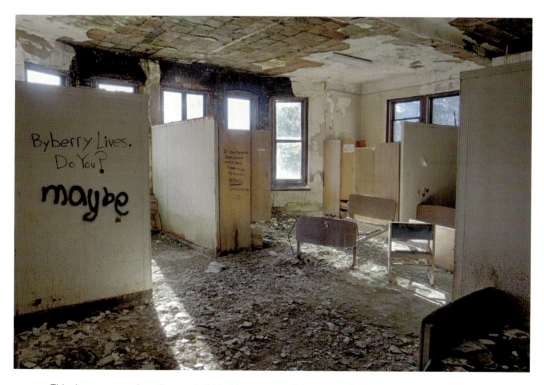

This day room may have been subdivided to accommodate more patients.

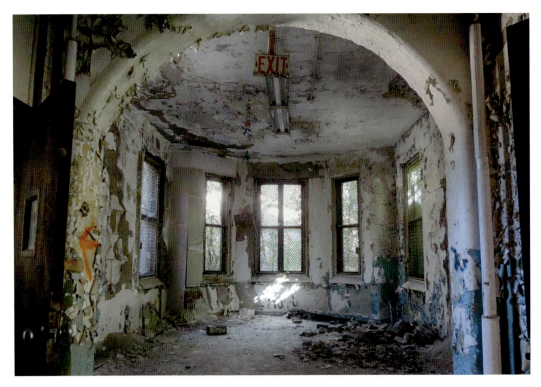

Notice the large grated windows at the end of the first-floor hallway in the female ward.

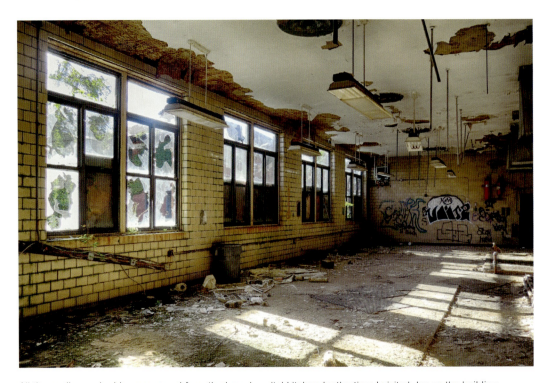

All the appliances had been removed from the large hospital kitchen by the time I visited. Ivy on the building across the road could be seen through the broken glass.

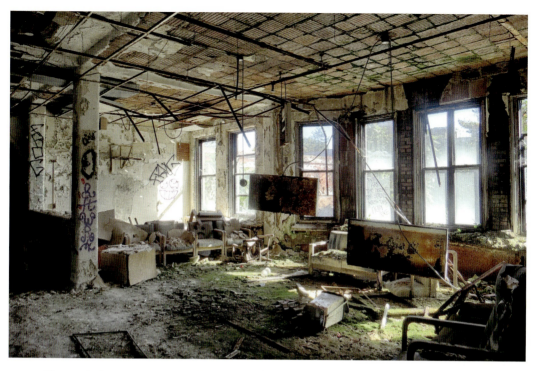

The panels from a newer drop ceiling had mostly fallen in this second-floor sitting room in the rehabilitation building. Moss was growing on the floor.

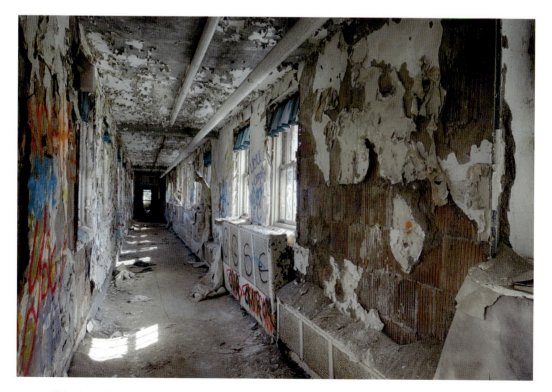

This elevated breezeway connected the rehabilitation and reception buildings.

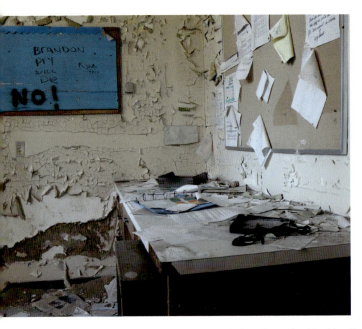
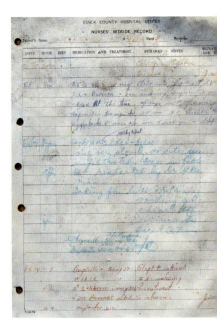

Above left: A binder and notes on the bulletin board remained in this office.

Above right: A nurse's bedside record for apparent treatment of a bacterial infection was among thousands of similar patient records left behind.

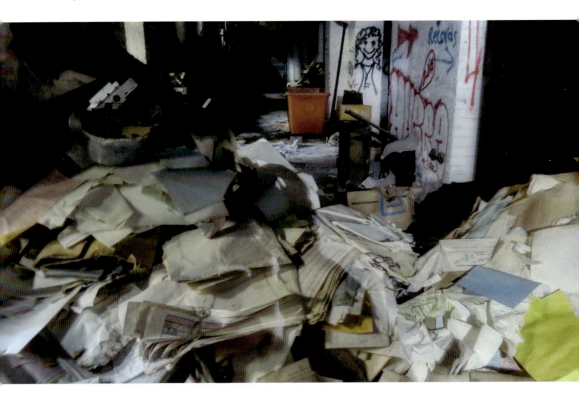

Shortly before demolition, a local historical society preserved some of this waist-high pile of patient files next to the records room in the basement of the rehabilitation building.

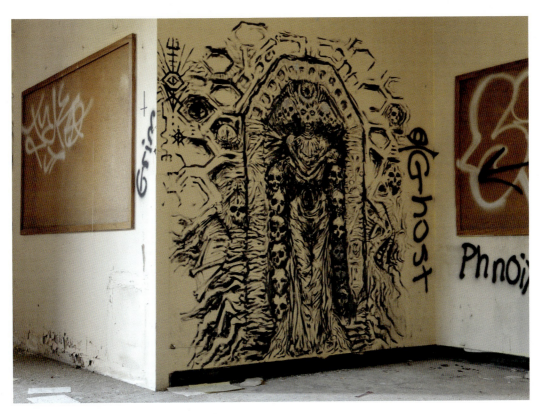

Highly detailed graffiti of this quality are rare.

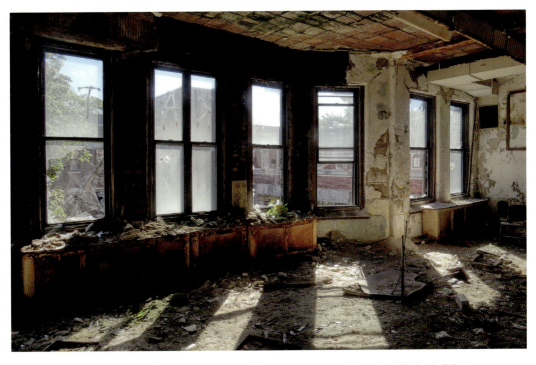

Plants grew from the radiator of another second-floor common area in the rehabilitation building.

New Jersey Sanitorium for Tuberculosis Diseases

In addition to Overbrook, there are other health-care institutions that remain vacant such as a former tuberculosis sanitorium on the grounds of the closed Hagedorn Psychiatric Hospital. Built in 1907 in the town of Glen Gardner, the sanitorium was the first institution erected on the site.[17]

Sanatoriums were treatment centers for long-term illnesses, especially tuberculosis in the era before antibiotics. With their wide, open-air porches, high ceilings and large windows for better air flow, these spaces were designed specifically to help heal people. Rest, fresh air and good nutrition were considered the best treatment for tuberculosis at the time.[18] The development at Rutgers University in the 1940s of streptomycin, the world's first effective antibiotic to treat a broad group of diseases, led to the hospital's closure in the 1950s.[19]

The site of the former tuberculosis hospital lay vacant for almost twenty years; in 1977, a new psychiatric facility was built next door. The unit was named after Senator Garrett W. Hagedorn in 1986 and used as a state nursing home and a 288-bed psychiatric hospital. But due to the growing movement toward deinstitutionalization, both private and large state-run psychiatric institutions began to close. This facility was shuttered in 2012 by then-New Jersey Governor Chris Christie in a budget-cutting move that was controversial because Hagedorn was the state's only psychiatric hospital for geriatric patients.[20, 21]

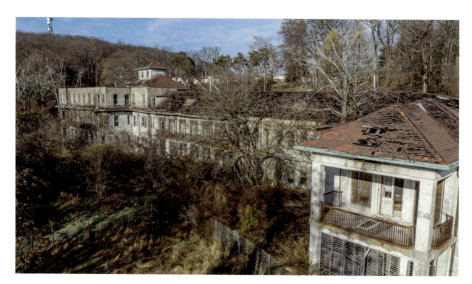

The design of the original New Jersey Sanitorium for Tuberculosis Diseases can be seen in this aerial photo. Many patient rooms opened out to a porch because fresh air was considered key to treating tuberculosis.

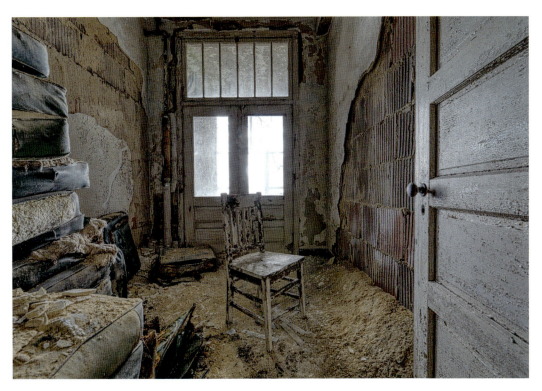

Mattresses remain stacked in this patient room.

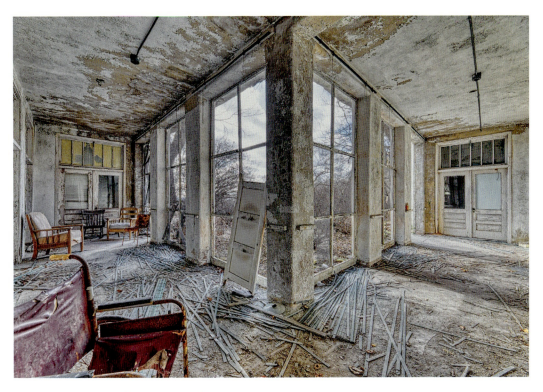

Chairs remain in this open-air porch.

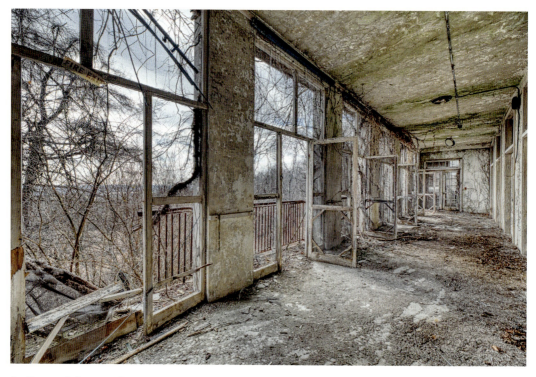

Another porch faces south.

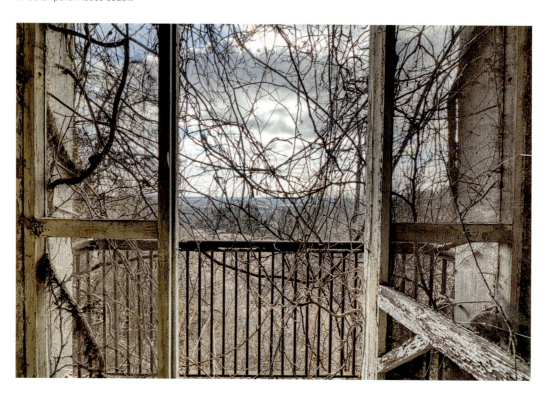

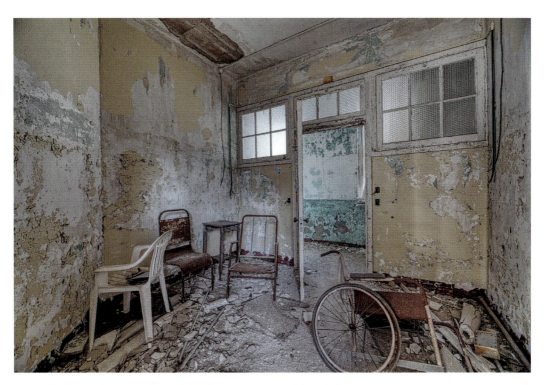

A wheelchair and other institutional furniture remain in this patient room.

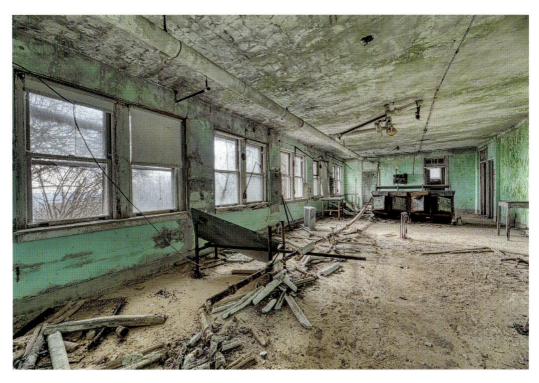

The purpose of this room is no longer clear, but from the fixtures remaining, it may have been related to food services.

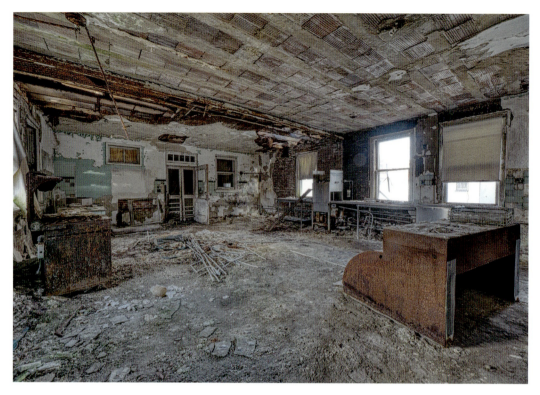

A stove and industrial dishwasher remain in a disintegrating kitchen.

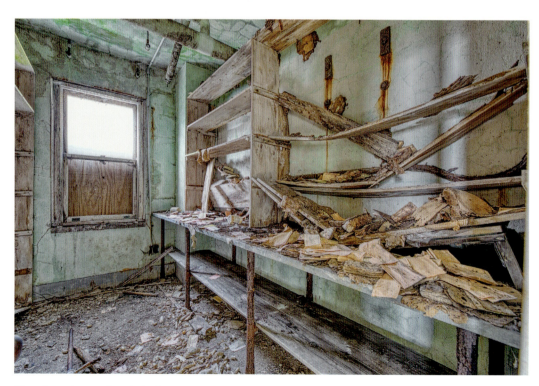

Piles of rotted papers line the broken shelves of this side room.

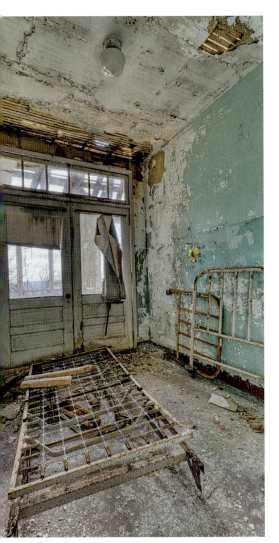

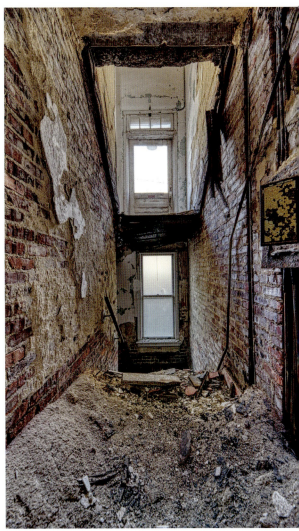

Above left: A metal bed frame slowly rusts in this patient room.

Above right and top of following page: The upper floors are inaccessible due to the collapsed stairways and gaping elevator shaft.

Below: Located in the basement, the morgue table, now filled with water, reflects the peeling paint on the walls.

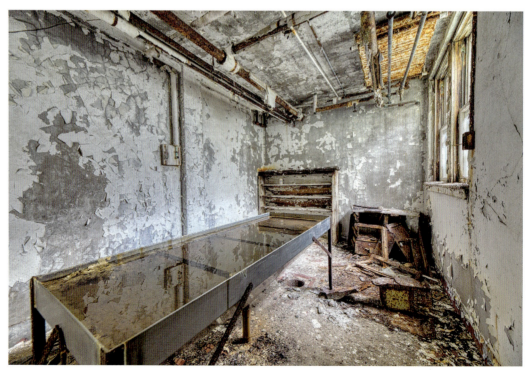

4

SCHOOLS

I t's an eerie feeling stepping into an institution that may feel so familiar to most of us but has fallen into disrepair. As I walk the halls of a school, behind the smells of mold and decay, I get the slightest hint of that old school smell. When I close my eyes, I imagine walking through my own school, kids running down the halls going to class. Then I open my eyes and it's desolate, dark, and disintegrating.

Schools are community centers, not just buildings children attend during the day. When a school closes, it's a major hit to the community and brings a sense of grief and uncertainty for residents.

According to Gene Demby, author of an NPR story about the loss of neighborhood schools, they "orient us to our own histories, anchors of continuity in the places where we were from. Schools are where young people first learn how to interact with their communities in official and personal capacities."[22] Because these places create a foundation for children and an anchor for neighborhoods, taking that away can have devastating effects in areas already lacking resources.

TRENTON JUNIOR HIGH NO. 1

The establishment of junior high schools was a goal of progressive educators in the early twentieth century. In 1916, Trenton established the first junior high in the East. Designed by prominent Trenton architect William A. Poland, the building was placed on the site of a former almshouse that had been constructed in 1871 on what had been a farm. In 1914, the school board purchased the almshouse property for $21,000. The news was met with skepticism by educators who were unsure if

this was the best site for the school. Despite concerns, the board continued with its plan and constructed the new building.[23] It was an imposing structure, designed with elaborate Collegiate Gothic architecture, a popular style for colleges and high schools in the early twentieth century.[24, 25]

The school, which included both a classroom building and a shop building, was built to accommodate 1,200 students. It opened with 929 in October 1916—two months late because Trenton children were under a quarantine due to a nationwide polio outbreak.[26] By the 1930s, the number of students began to grow, eventually surpassing 1,400. Classes increased from thirty to forty pupils, resulting in over-crowding. Eventually five junior high schools were built. Trenton Junior No. 1 was initially integrated but became segregated after 1924, when African American students were moved to the newly built Lincoln School.

Two African American mothers, Gladys Hedgepeth and Berline Williams, chal-lenged Trenton's school segregation in 1943. In 1944, the New Jersey Supreme Court, in *Hedgepeth and Williams v. Board of Education*, held that racial segrega-tion was illegal according to New Jersey law, and in 1945, Trenton schools were desegregated. The Hedgepeth decision was an important steppingstone for the U.S. Supreme Court's pivotal 1954 *Brown v. Board of Education* decision.[27]

This Trenton junior high eventually closed in 2006 due to a dramatic decline in student population and competition from charter and parochial schools.[28] The city's overall population had dropped from its peak in 1950 of 120,000 people to 85,400 in the year 2000, losing about 29% of its population.[29] The building was left unused for years and is deteriorating and heavily vandalized. In 2019, the city and the Trenton Housing Authority won a three-year $1.3-million federal grant to explore the revitalization of the distressed neighborhood surrounding the school. An experienced Philadelphia-based urban design firm is coordinating the planning.[30] Reuse of the school for senior housing has been discussed.

Trenton Junior High No. 1 is an excellent example of how photographers who document abandoned places can lead to the resurrection of a building's history, if not the building itself. Pictures of the school's decay (posted on Facebook by photographers J. Carlos Vargas, who attended the school in the 1980s, and Robert J. Sammons) led Karl J. Flesch, a trustee of the Trenton Historical Society, to research the school's history and eventually curate "On the Forefront: The Junior No. 1 Stories," a physical and virtual exhibit for the Trenton City Museum at Ellarslie. The exhibit ran during the Covid-19 pandemic, from the fall of 2020 through the spring of 2021, with timed entries at the museum and online in Zoom presentations. Readers interested in learning more about Junior High School No. 1 should start here: ellarslie.org/on-the-forefront-trentons-junior-no-1-1916.

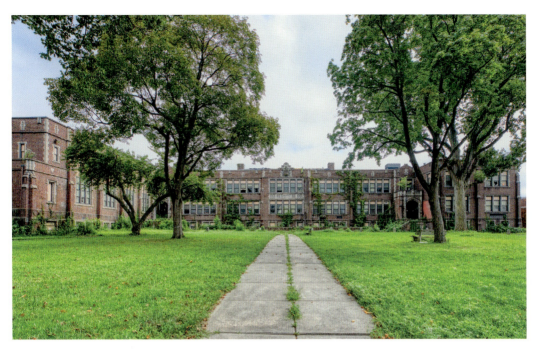

Junior High No. 1 in Trenton opened in 1916 and was in use for ninety years. Elements of the Collegiate Gothic architecture such as windows, doorways, and interior design were organized in threes to symbolize the Holy Trinity. Originally the doors on either side were separate entrances for girls and boys.

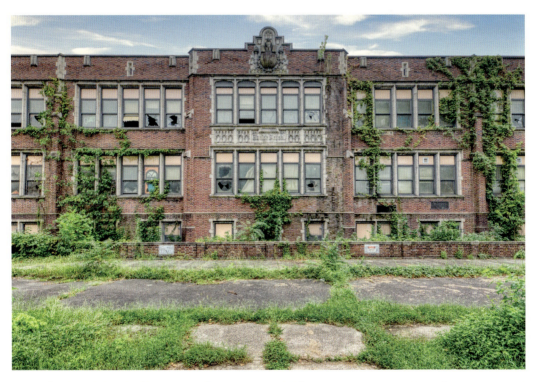

The front of the school has some elaborate stonework. At the top center is a statue of an owl standing on top of a globe. It symbolizes the wisdom of the world, according to Albert Williams, a former principal.

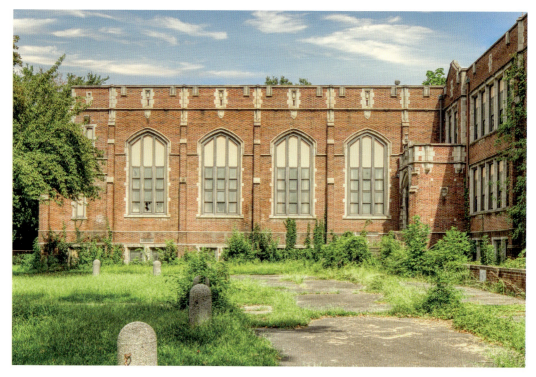

At the front of the school, you can see the outside of the auditorium with large Gothic-style windows. Note each window is divided into three vertical sections.

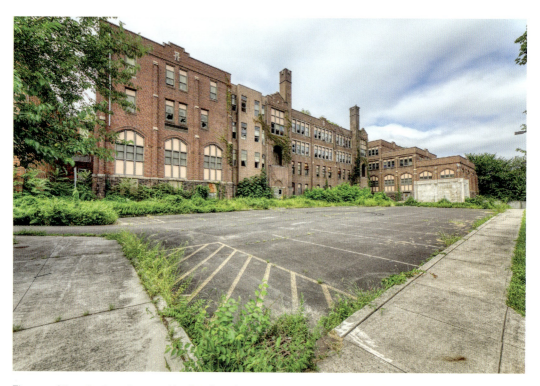

The rear of the school now has a parking lot where the original shop building used to be.

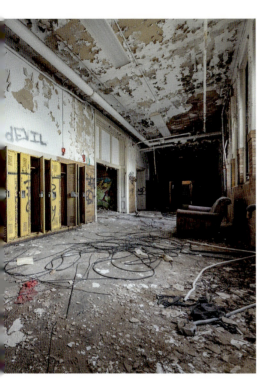 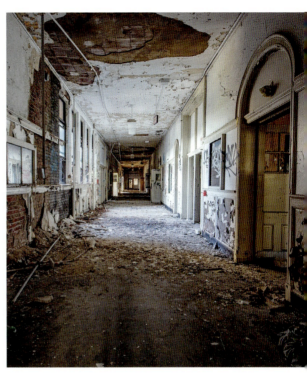

Above left: Long ago the hallways were crowded with students changing classes.

Above right: This dilapidated hallway leads to the auditorium on the right.

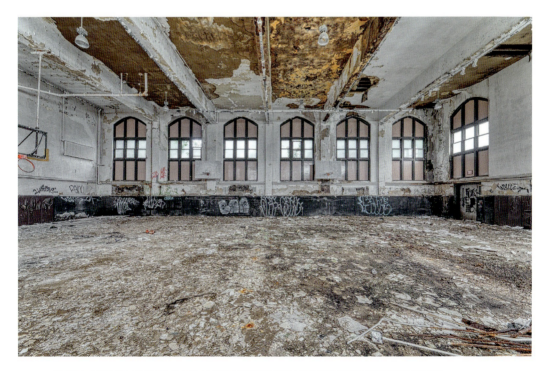

Ceiling plaster has fallen to the floor of the heavily damaged gym at the rear of the school.

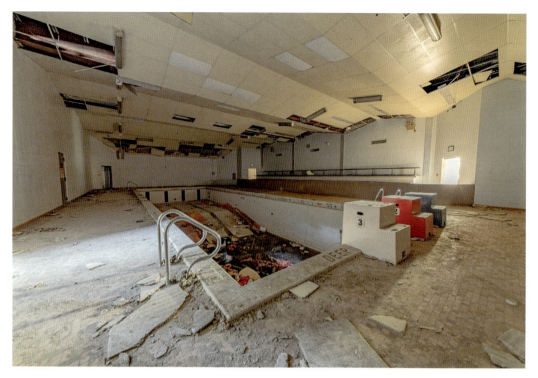

A large pool was a 1965 addition.

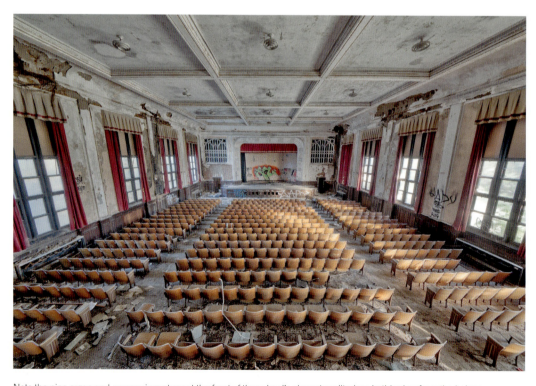

Note the pipe organ and proscenium stage at the front of the school's elegant auditorium in this view from the balcony.

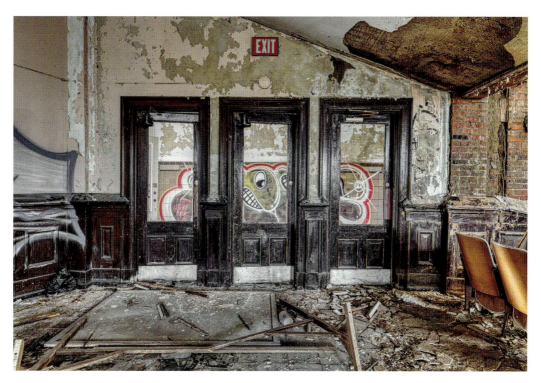

In another element of Gothic style, three doors open out from the auditorium.

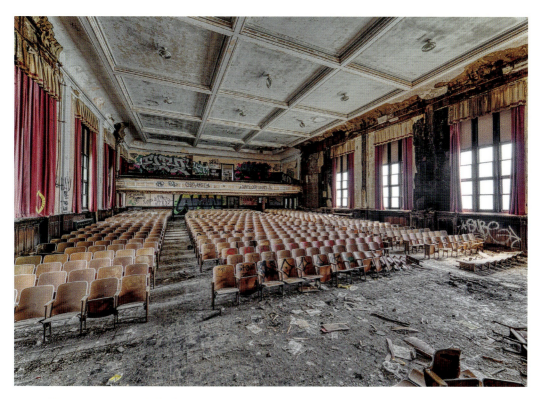

Three pillars support the balcony.

NEWARK SCHOOL

In 1851, this Newark school was built. The building was renovated multiple times throughout its history (enlarged 1861-9, 1881, 1898, and 1909).[31] In the early 1900s, the original building was demolished, and a structure designed by Ernest Guilbert replaced it. This new school matched the old building but included a 65,000-square-foot addition, a 750-seat auditorium, thirty-five classrooms, a gym, and playground. While the exterior is a fairly generic brick five-story building, the interior design is beautiful, with a stunning neoclassical auditorium at the heart of the building and open hallways surrounding it.

The facility closed in 2007 and students were moved to area schools. It was later used for a charter school, then a magnet school, and in 2016, the property was conveyed along with others to the Newark Housing Authority, which sold it in 2018. Looters and vandals have accessed the building, and today it's in ruins. Unfortunately, the amount of damage makes it almost impossible to save the building and current assessments show it's very unsafe.[32]

A community effort is under way to preserve the heritage of the Newark school district, one of the oldest in the nation. More information is available from the Newark Public Schools Historical Preservation Committee: www.npshpc.org.

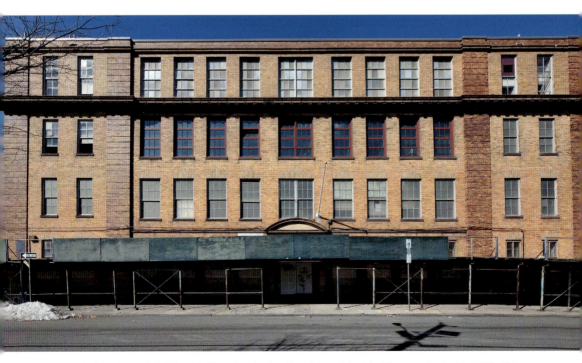

Built in the early 1900s, this Newark school replaced the original building constructed in 1851. This view is of the front entrance.

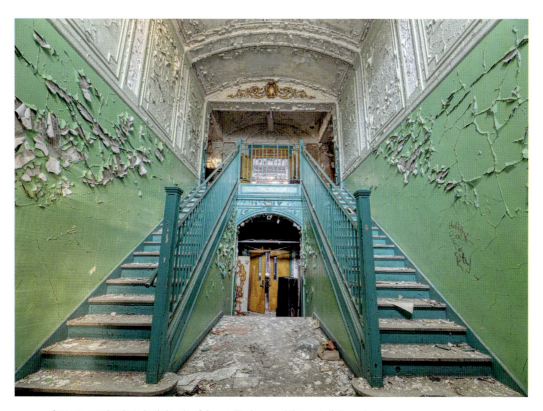

An entryway leads to both levels of the auditorium and the rest of the school.

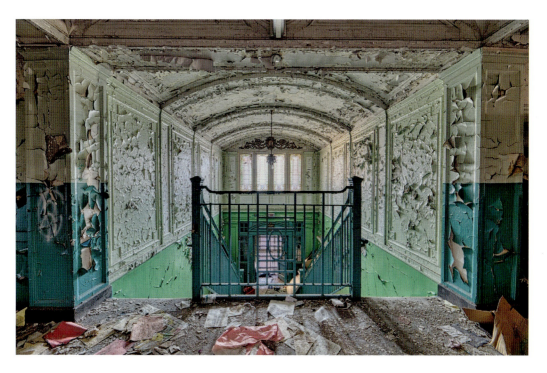

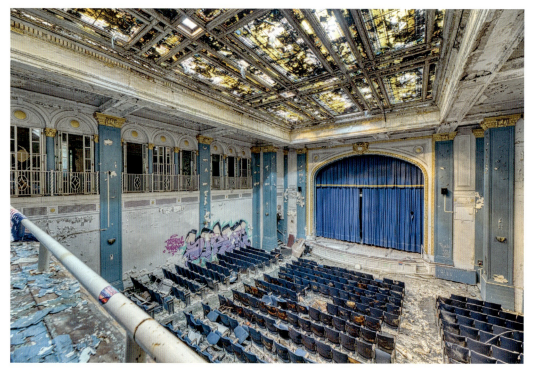

The stunning neoclassical auditorium, now heavily vandalized with graffiti, still shows elements of its original grace.

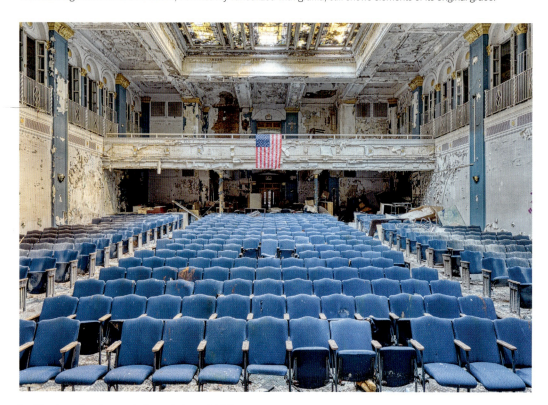

Looking from the stage, note the upholstered folding seats.

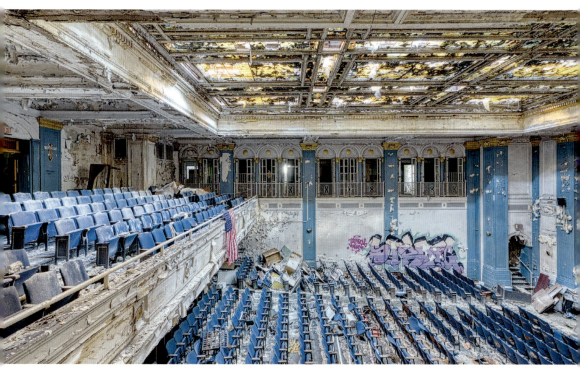

The side hallways look into the auditorium.

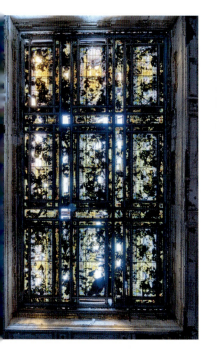

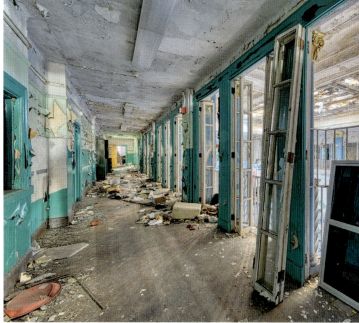

Above left: Looking upward from the main seating area, students would have seen the auditorium's beautiful stained-glass skylight, now filthy and partially broken.

Above right: Multiple French doors open out to the auditorium from this side hallway.

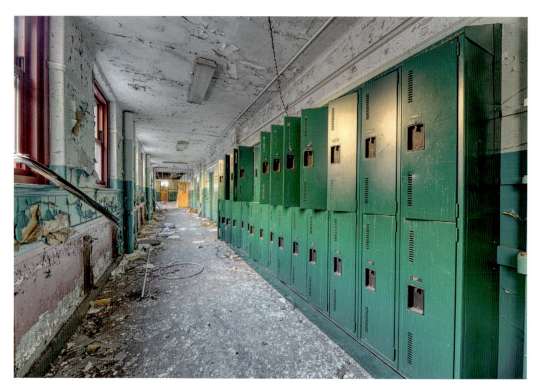

A hula-hoop and dominos lay on the floor of a hallway.

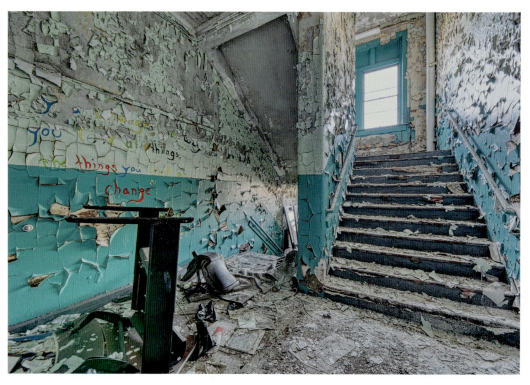

A quote on the wall reads, "When you change the way you look at things, the things you look at change."

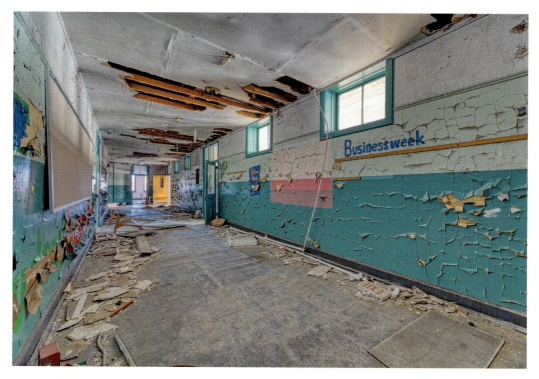

A hallway is decorated with motivational messages as well as the names of business magazines including *Forbes* and *Businessweek*.

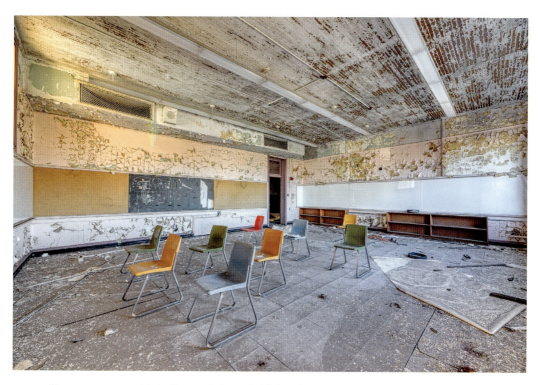

Classrooms were updated with new chairs and whiteboards.

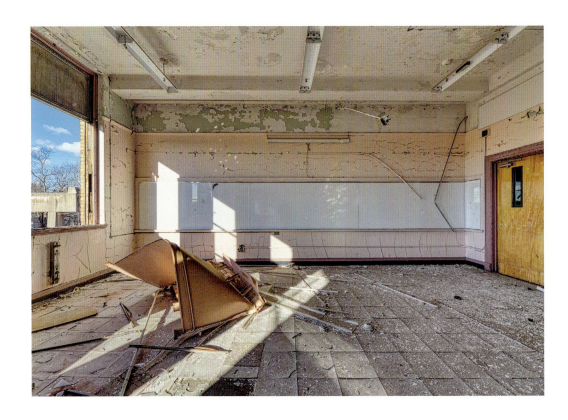

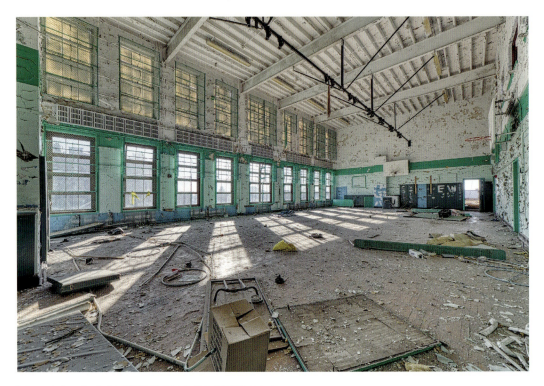

Large windows for natural light illuminate this third-floor gym.

5

CHURCHES

D riving through cities across New Jersey, beautiful old church buildings are hidden waiting to be discovered. I find churches fascinating because the amount of their architectural detail is extraordinary, and at one time, they were vital parts of their communities. But religious institutions have been slowly declining over the past decades. Since the turn of the century, the percentage of U.S. adults with no religious affiliation has increased and fewer than 50% belong to a church, synagogue, mosque, or other religious institution.[33] Many congregations are unable to take care of their facilities as they lose members. Maintaining these beautiful, grand places of worship is expensive, and so congregations close their doors.

THE TRENTON CHURCH

The first time I visited this abandoned church in Trenton, built in 1874, I expected little. Because of the poor condition of the entryway, I imagined the place to be a mess. To my surprise, when I walked into the sanctuary, it was in fairly good condition aside from some broken windows and some graffiti on a few of the walls. Given this building's rich history, I find its deterioration particularly sad.

The Presbyterian population of Trenton grew rapidly in the 1850s, with two churches in the center of town and two others on the outskirts. On August 11, 1874, the cornerstone of this church was laid and on April 25, 1875, it opened with thirty-five members.[34] It soon became one of Trenton's largest and most prestigious congregations. The church prospered for many years, but by the mid-1940s, as its members aged and many moved to the suburbs, attendance declined. Membership

continued to fall over the years and the church officially closed in 1993. It saw new light when another congregation, whose official charter was granted in the summer of 1994, opened with "77 members and grew to 110 between 1995 and 1998." That church held its last service in August 2006, but the community center within it remained open for events until 2007, when the property was sold.

Today the city owns the property and would like to revitalize the area. Several groups have expressed interest, but no obvious work has been done.[35] The building sits rotting away with parts of its roof collapsing. Fortunately, the roof of the sanctuary appears to be in sound condition.

I visit this church from time to time because it's a beautiful structure and deserves a brighter future. When talking to area residents about it, some shrug and say, "It's been abandoned as long as I've lived here." I always enjoy speaking to neighbors about these mysterious places, because you never know what they might have to share. It might be that they simply don't know anything about it, or they may have a rich and detailed account of what the building used to be.

As of August 2021, the church sits vacant. Over the past few years I've observed the structure gradually becoming more unstable. A collapsed section of roof near the entryway has become more and more of a hazard each time I've gone by.

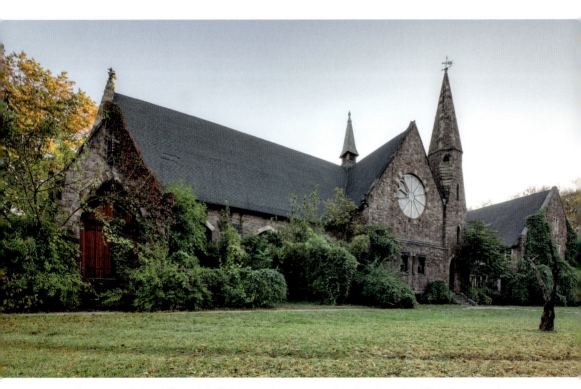

Due to population shifts and declining attendance, some churches throughout New Jersey, such as this one in Trenton, are unused.

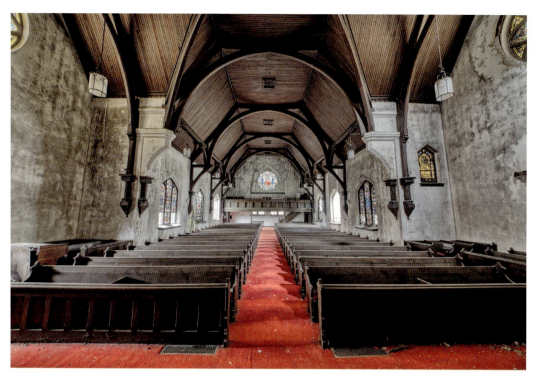

The view from the altar includes the choir loft at the end of the sanctuary.

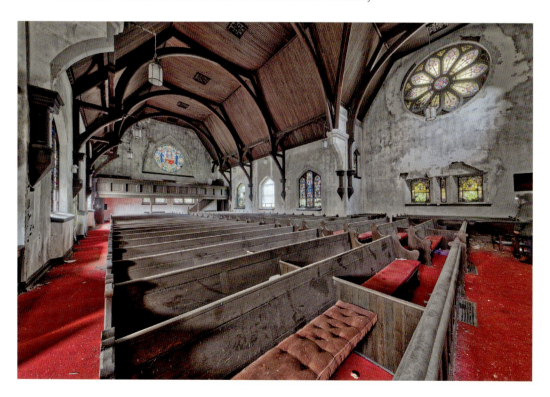

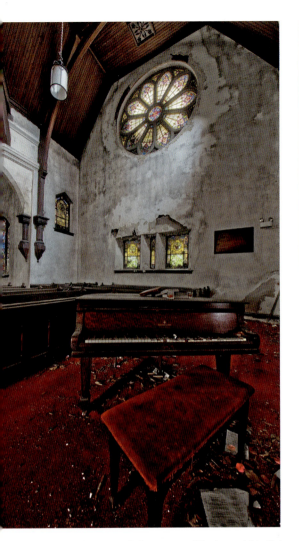

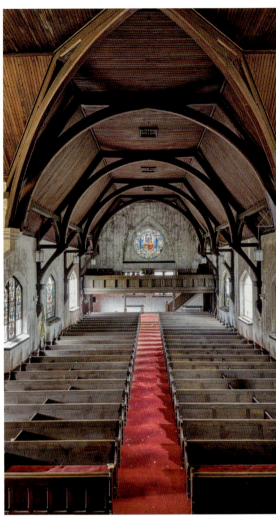

Above left: Ivory peels from some of the keys of this Steinway piano below a gorgeous rose window.

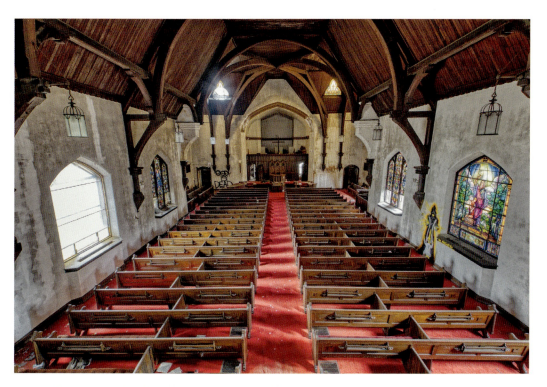

The choir would have had this view of the nave and the pulpit.

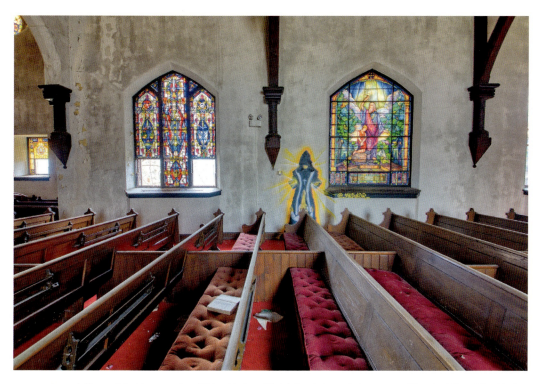

A vandal has painted irreverent graffiti beside beautiful stained-glass windows, one with a depiction of the binding of Isaac labeled "Sacrifice."

ABOUT THE AUTHOR

JOEL NADLER is a photographer from Central New Jersey who got his start exploring an abandoned county mental hospital in northern New Jersey. Fascinated with the historic place, he went on to produce a short documentary focused on the hospital's importance within the local community.

Joel started his journey in photography while attending Goucher College and studying at the Glasgow School of Art. Intrigued by the history of abandoned places, he began documenting more of them through his photography. His bachelor's degree in historic preservation and communications created a perfect foundation for this type of photography. Joel is proud to share his images and impressions of these lost places and is eager to tell you what it's like to explore them.

ENDNOTES

1. "A Short History of New Jersey," www.nj.gov/nj/about/history/short_history.html
2. 2014 New Jersey Revised Statutes, "Determination that property is abandoned," law.justia.com/codes/new-jersey/2014/title-55/section-55-19-81/
3. "The New Jersey Economic Recovery Act," www.njeda.com/economicrecoveryact/
4. "Glen Alpin," www.preservationnj.org/listings/glen-alpin/
5. "The Great Story," njskylands.com/hsmtnhp
6. Harding Township Civic Association, "A Glen Alpin Overview," hardingcivic.org/wp-content/uploads/2017/02/SR-GlenAlpin2006Mar04.pdf
7. "The History of Movies in NJ," www.nj.gov/nj/about/arts/movies.html
8. "A History of Film in Fort Lee, NJ," www.barrymorefilmcenter.com/history
9. M. Nartinez, "Paramount Theatre," cinematreasures.org/theaters/4603
10. M. Lambros, "The Newark Paramount Theatre," afterthefinalcurtain.net/2011/09/28/the-newark-paramount-theatre/
11. M. Lambros, "After the Final Curtain: Abandoned Theaters of New Jersey," untappedcities.com/2012/11/29/after-the-final-curtain-abandoned-theaters-of-new-jersey/
12. EsseXploreR, "The Newark Paramount Theatre," tfpnj.blogspot.com/2015/11/the-paramount-theater.html
13. archive.centraljersey.com/2005/06/03
14. A. Norwood, "Dorothea Dix," www.womenshistory.org/education-resources/biographies/dorothea-dix
15. "A Farewell to Overbrook Asylum (Essex County Hospital)," weirdnj.com/stories/abandoned/overbrook_essexcountyhospital/
16. J. Mazzola, "Hospital's haunted history is over -- park and townhomes moving in," www.nj.com/essex/2017/01/hospitals_haunted_history_is_over_park_and_townhom.html

17. upward2bound, "Abandoned Hagedorn Psychiatric Hospital," www.atlasobscura.com/places/new-jerseys-abandoned-hospitals

18. A. Kanabus, "Information About Tuberculosis," tbfacts.org/sanatorium/

19. "Rutgers Discovery That Changed the World May Become New Jersey's State Microbe," www.rutgers.edu/news/rutgers-discovery-changed-world-may-become-new-jerseys-state-microbe

20. S. Spies, "QUERY: History of Hagedorn Psychiatric Hospital," lists.h-net.org/cgi-bin/logbrowse.pl?trx=vx&list=h-new-jersey&month=0701&week=b&msg=ILO9%2BcuS16i5fVpM5kiX5Q&user=&pw=

21. S. Livio, "Closure of Hagedorn Psychiatric Hospital has patients' families worried," www.nj.com/news/2011/07/hagedorn_psychiatric_hospital.html

22. G. Demby, "What We Lose When A Neighborhood School Goes Away," www.npr.org/sections/codeswitch/2015/09/14/439450644/what-else-we-lose-when-a-neighborhood-school-goes-away

23. "Trenton Junior High School No. 1," ellarslie.org/wp-content/uploads/2020/10/Junior-No.-1-After-Dedication.pdf

24. "North Ward Historical Resource Survey: City of Trenton," www.trentonhistory.org/northwardsurvey.html

25. "William A. Poland (1852-1935," ellarslie.org/wp-content/uploads/2020/10/Poland.pdf

26. "Building Junior No. 1," ellarslie.org/wp-content/uploads/2021/01/Building-the-School.pdf

27. "The Segregation/Desegregation of Trenton Schools," ellarslie.org/wp-content/uploads/2021/03/ON-THE-FOREFRONT-Segregation-Desegregation-Story.pdf

28. "School Days - A Talk With Former Principal Albert Williams and Teachers," March 24, 2021. www.youtube.com/watch?v=7-1K5Y71VXA

29. World Population Review, "City of Trenton," worldpopulationreview.com/us-cities/trenton-nj-population

30. WRT LLC press release, "Trenton, NJ receives $1.3 million HUD Choice Neighborhoods Planning and Action Grant," Sept. 26, 2019, www.wrtdesign.com/about/news/trenton-nj-receives-1-3-million-hud-choice-neighborhoods-planning-and-action-grant

31. Newark Board of Education, "District History," www.nps.k12.nj.us/info/district-history/

32. Newark Public Schools, "Chronology and School Buildings," www.npshpc.org/wp-content/uploads/2020/02/Chronology.pdf

33. J. Jones, "U.S. Church Membership Falls Below Majority for First Time," news.gallup.com/poll/341963/church-membership-falls-below-majority-first-time.aspx

34. "1859-1884." History of the Presbyterian Church in Trenton, N.J., by John Hall and Mary Anna Hall, 2nd ed., MacCrellish & Quigley, 1912.

35. C. Rojas, "Proposals sought to redevelop neglected Trenton church," www.nj.com/mercer

BIBLIOGRAPHY

Cragoe, Carol Davidson, *How to Read Buildings: A Crash Course in Architectural Styles* (New York: Rizolli, 2008)

Hall, J. and M., *History of the Presbyterian Church in Trenton, N.J.* (Trenton: MacCrellish & Quigley, 1912)

Poppeliers, John C. and S. Allen Chambers, Jr., *What Style Is It? A Guide to American Architecture* (Hoboken, NJ: John Wiley, 2003)

Tyler, Norman, Ted. J. Ligibel, and Ilene R. Tyler, *Historic Preservation: An Introduction to Its History, Principles, and Practice*, 2nd Edition (New York: W. W. Norton, 2009)

Witzel, Michael Karl. *The American Diner* (New York: Crestline, 2006)